Animal Kingdom

Millie Marotta

New York

An Imprint of Sterling Publishing
1166 Avenue of the Americas
New York, NY 10036

First published in the United Kingdom in 2014 by Batsford, an imprint of Pavilion Books Group Ltd, as Millie Marotta's Animal Kingdom: Colour Me, Draw Me

ISBN 978-1-4547-0910-7

Distributed in Canada by Sterling Publishing
c/o Canadian Manda Group, 664 Annette Street
Toronto, Ontario, Canada M6S 2C8

For information about custom editions, special sales, and premium and corporate purchases, please contact Sterling Special Sales at 800-805-5489 or specialsales@ sterlingpublishing.com.

Manufactured in Canada

14 16 15 13

larkcrafts.com

Animal Kingdom

Color Me, Draw Me

Millie Marotta

LARK

Introduction

I grew up on a small farm in rural west Wales and it is there that I would say my obsession with all things flora and fauna first began. All those years spent in the countryside, very much immersed in nature, firmly cemented my fascination with the natural world. My favorite pastimes would usually involve either some element of drawing, painting — and generally making a bit of a mess — or playing outside with any one of the many family pets. Imagine my delight when later on I discovered that I could study Wildlife and Illustration together, which is what I went on to do. When I look back now I suppose my path was always mapped out, though I didn't realize it at the time.

I have always been in awe of animals in all their glorious forms — from tiny beetles creeping about beneath leaves in the back garden to the elaborate birds of paradise found in the canopies of tropical rainforests. The captivating charm of the natural world is what brings me back to drawing animals time and time again — it is bursting with an extraordinary array of visual treats.

This book brings together a collection of enchanting fish, birds, mammals, reptiles, invertebrates and amphibians. Although this is ultimately a book of animals, you will also find some plants, trees and flowers included in its pages, among which you may discover the odd bug hiding out. You will also find a scattering of words to help you along the way, with suggestions of how or what you might add. It is a celebration of the animal kingdom as much as it is a coloring and doodle book, waiting for you to lose yourself among the pages.

My illustrations usually begin as quite simple but realistic drawings of the creature. I keep the general form of the animal relatively true to life, but will then begin to elaborate with lots of intricate patterning and detail.

All the drawings in this book begin in black and white. Some might remain so, while others will be flooded with color. Some will invite you to be even more adventurous and join in by adding

your own patterns and textures. These choices are yours to make. On some pages you will find areas of the illustrations have been left empty, crying out for you to embellish in any way you wish. You may choose not to add any color at all to some and instead just add your own doodles to decorate the animal or add drawings to create a fantastic habitat for the creature. All the drawings in this book were created using a Rotring Rapidograph fine liner, which I use for almost all my work. You can use any pen you choose when it comes to adding your own details to the pages. The finer the pen, the more detail you will be able to add.

For adding color, I would suggest using colored pencils rather than felt pens as they are more versatile, allowing you the ability to blend colors and add shading if you wish. You may find some parts of certain drawings are too detailed to color in every tiny little section, and so you may choose to simply color over the top of these areas, allowing the textures and patterns underneath to show through.

At the end of the book you will find a few empty pages waiting to be brought to life by you. You might want to try making a copy of your favorite illustrations from the book, or you may be feeling confident enough to draw something entirely your own. Whatever you decide to include on these pages they are there for you to fill with your own animal kingdom. The important thing is that while this may be a book of my drawings to begin with, by the time you have finished, you will have made it your own and it will be uniquely yours.

Millie Marotta

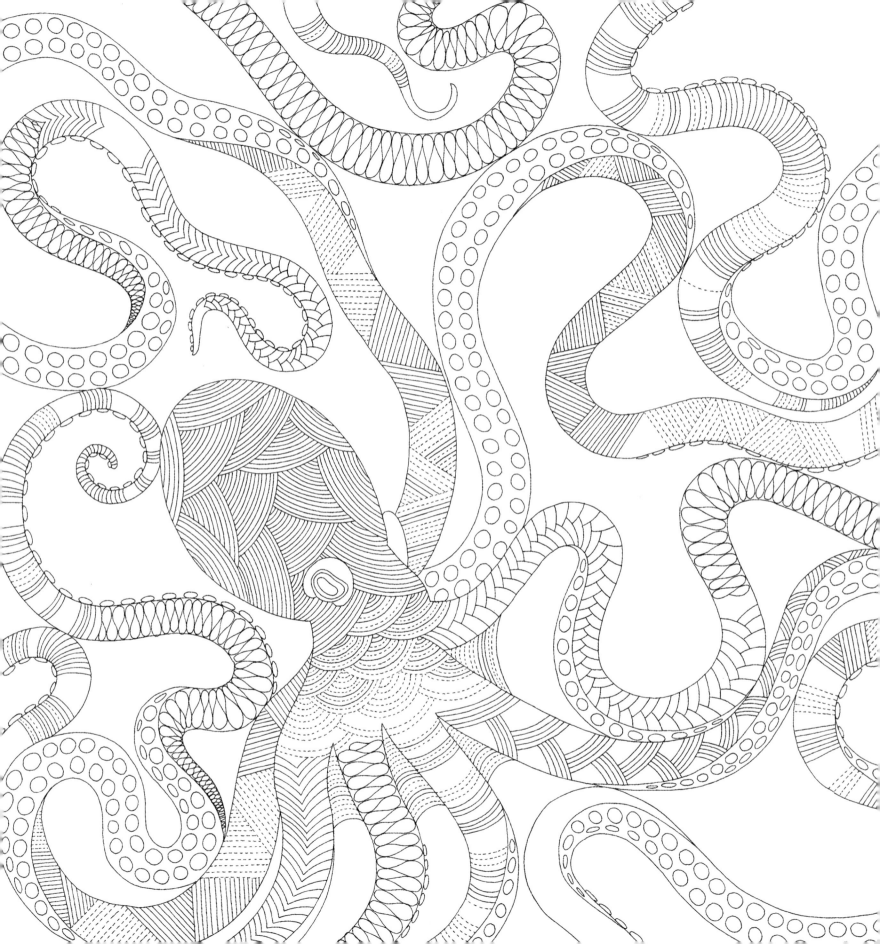

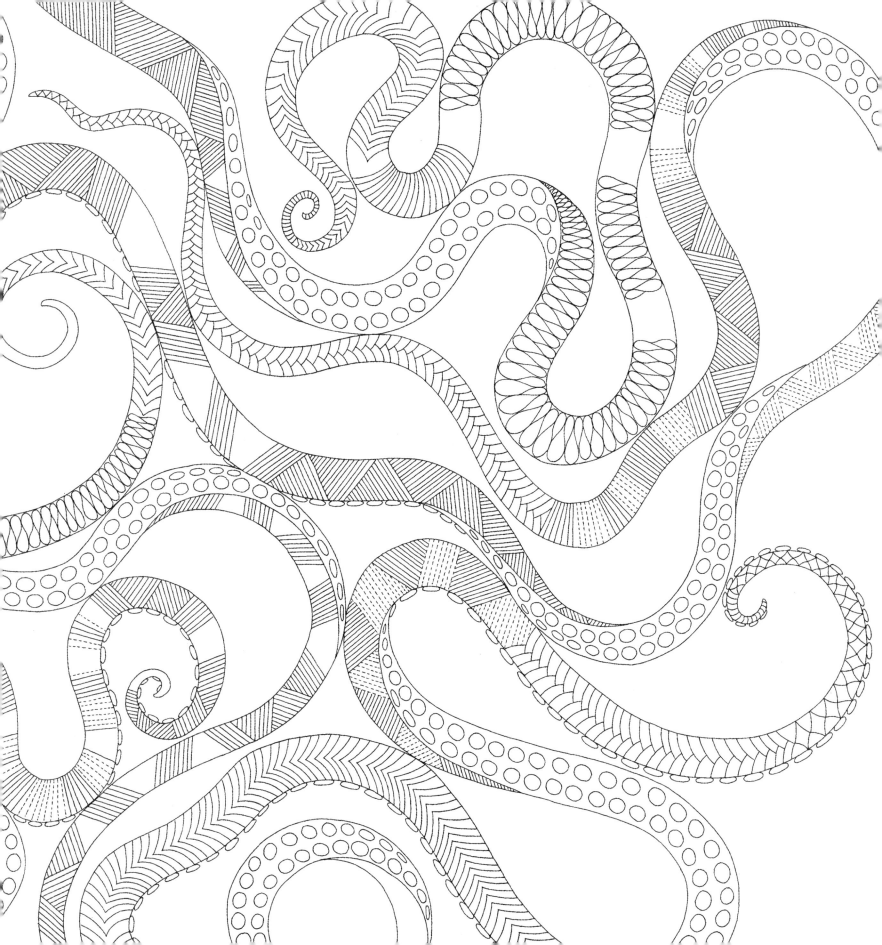

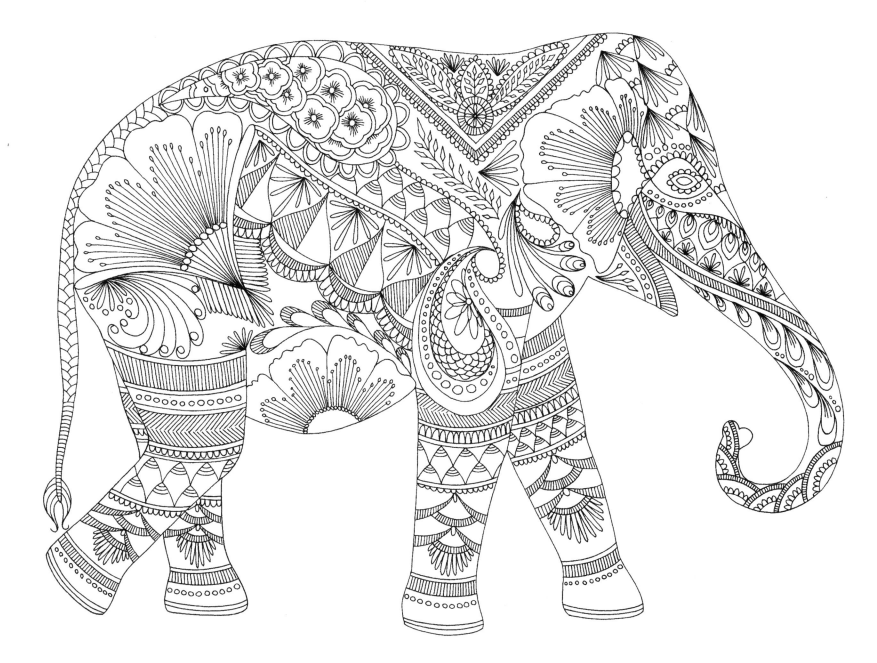

The majestic Asian elephant loves to stand out. Add some decorative shapes and botanical prints to his belly.

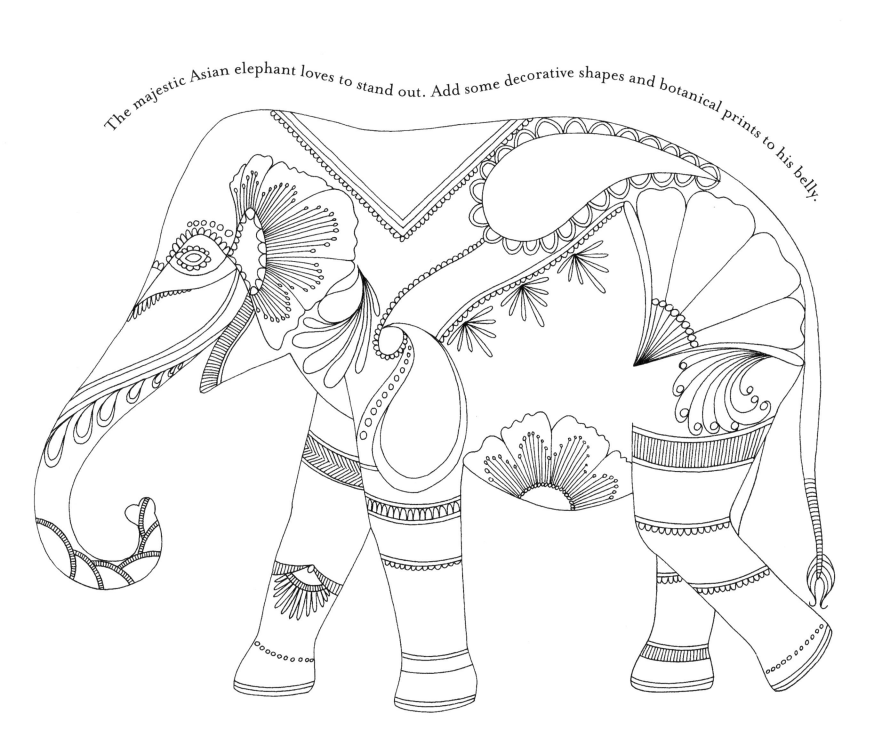

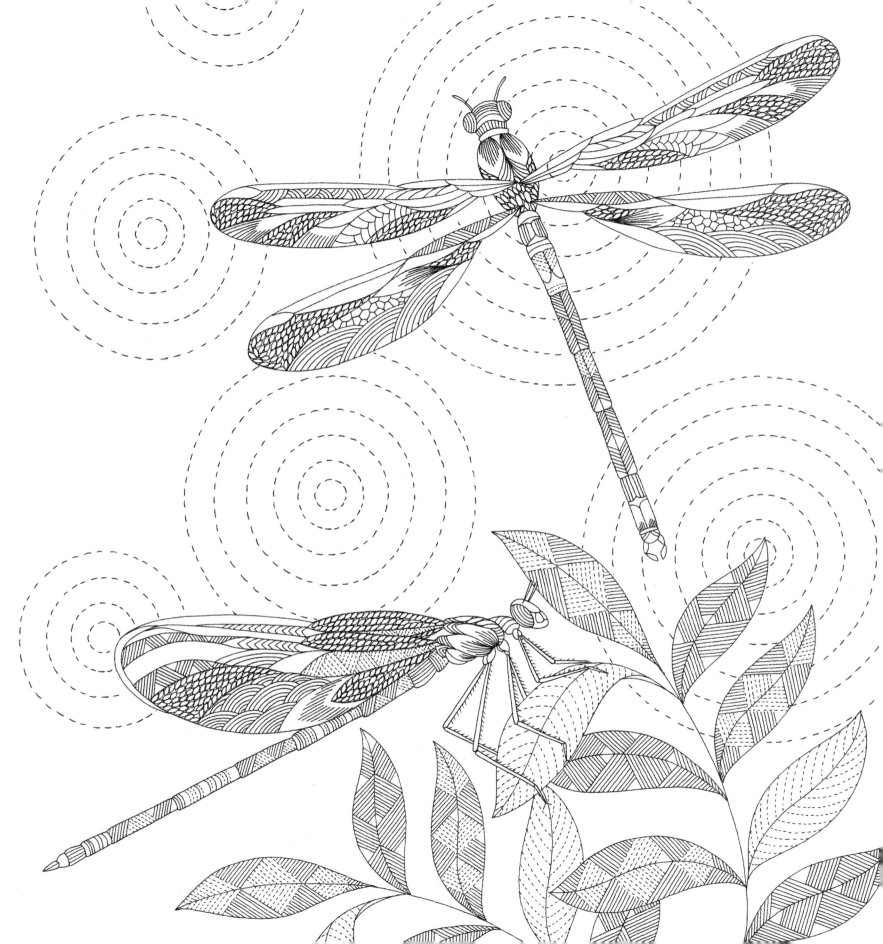

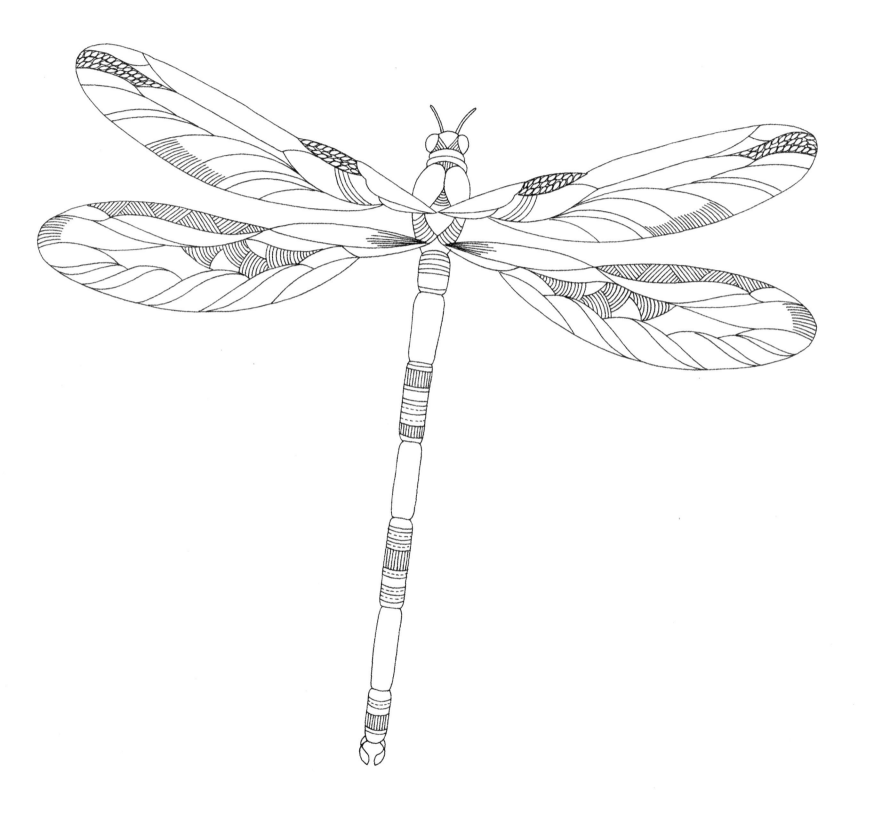

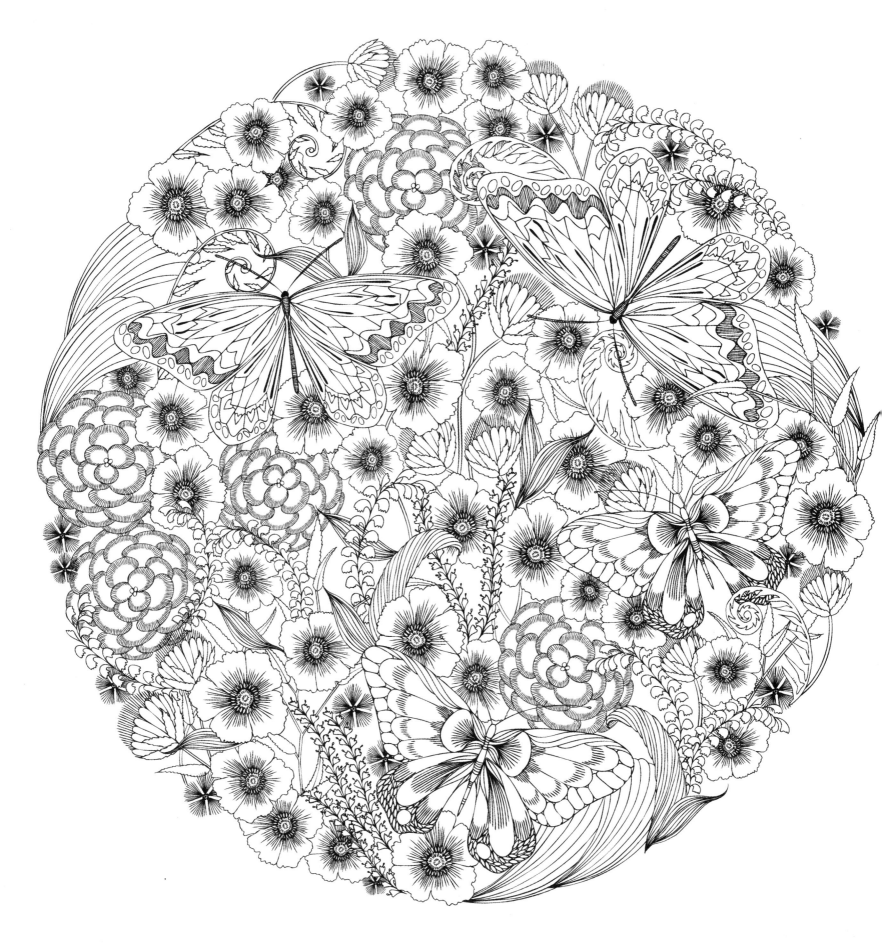

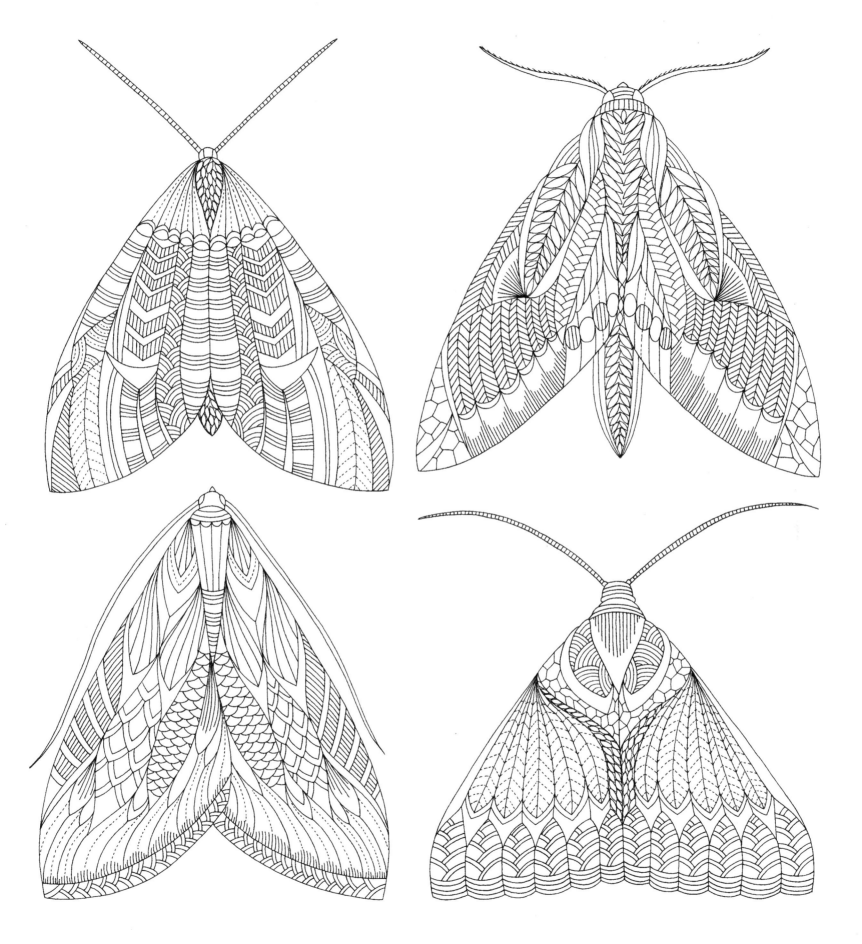

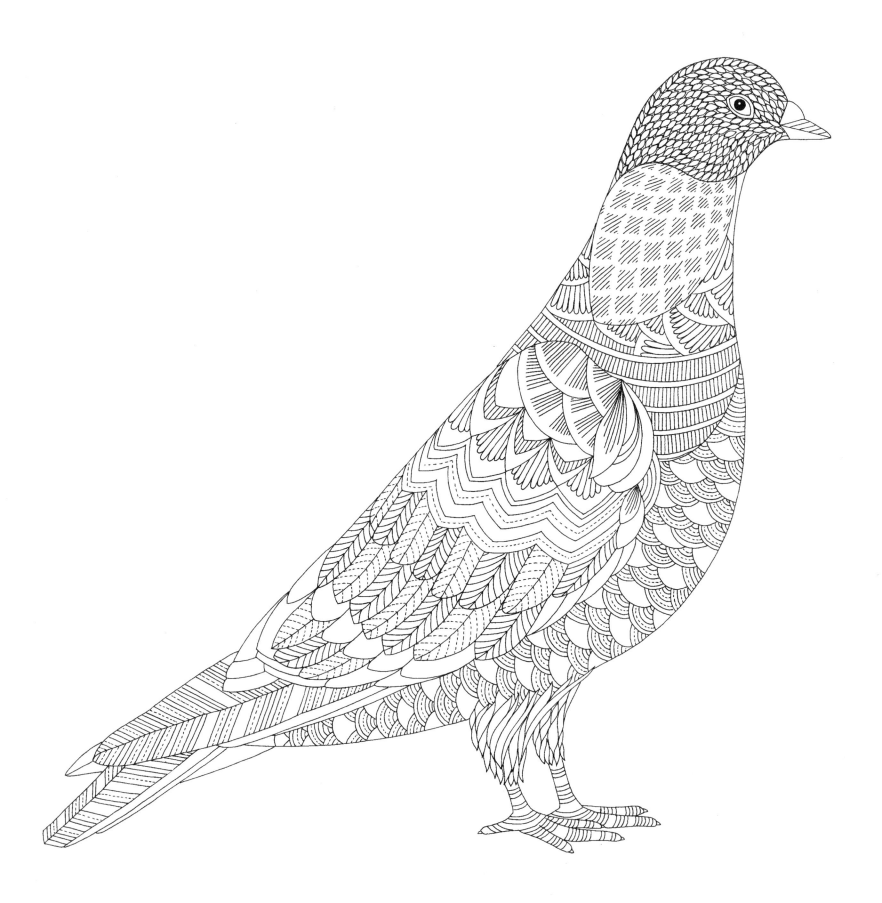

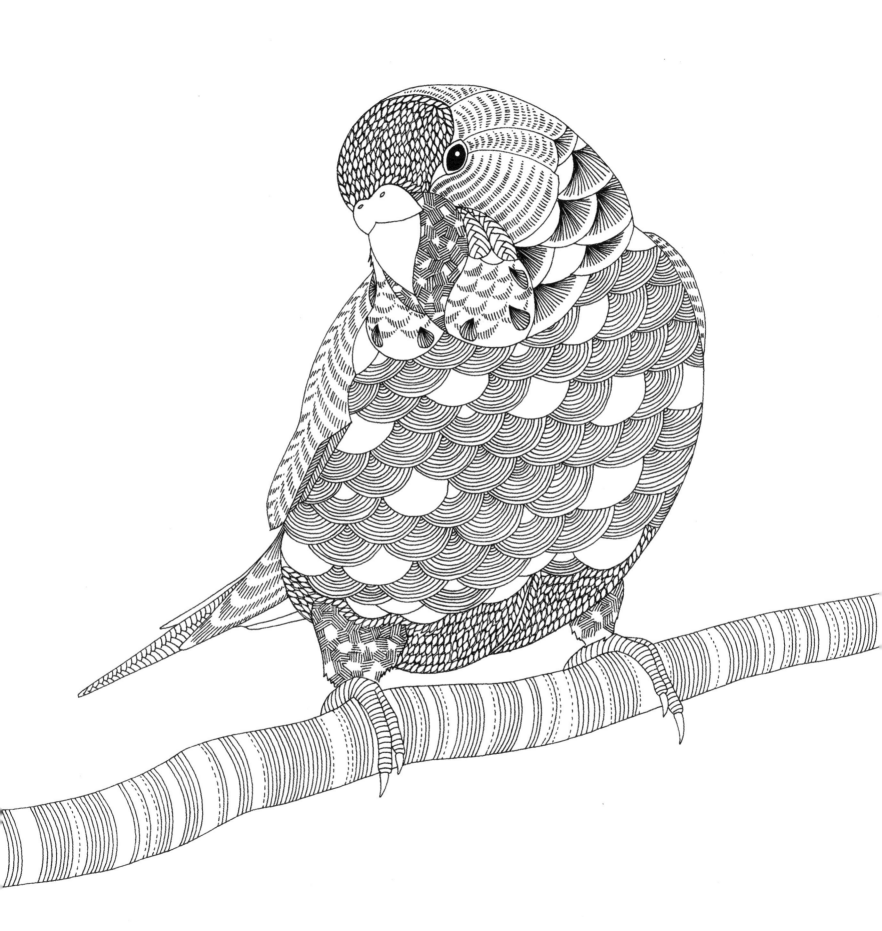

Add some color to the bandit-masked raccoon.

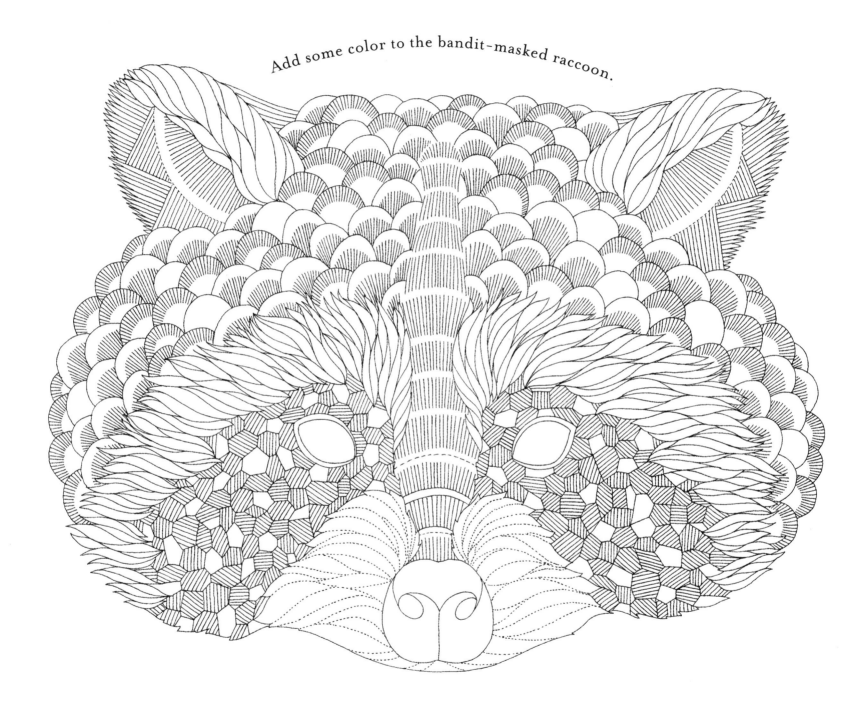

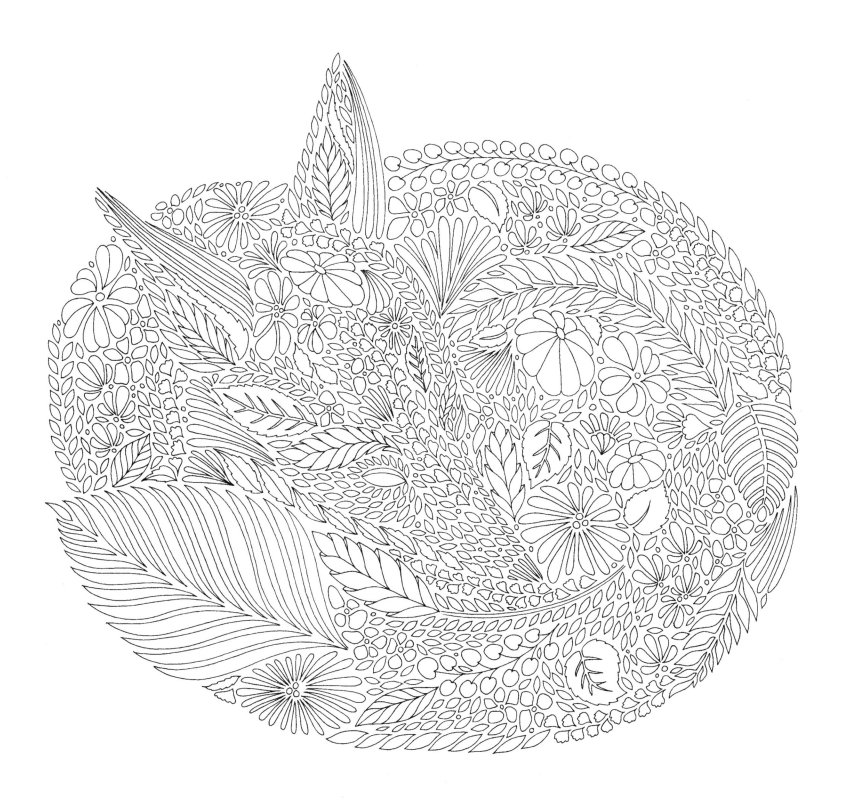

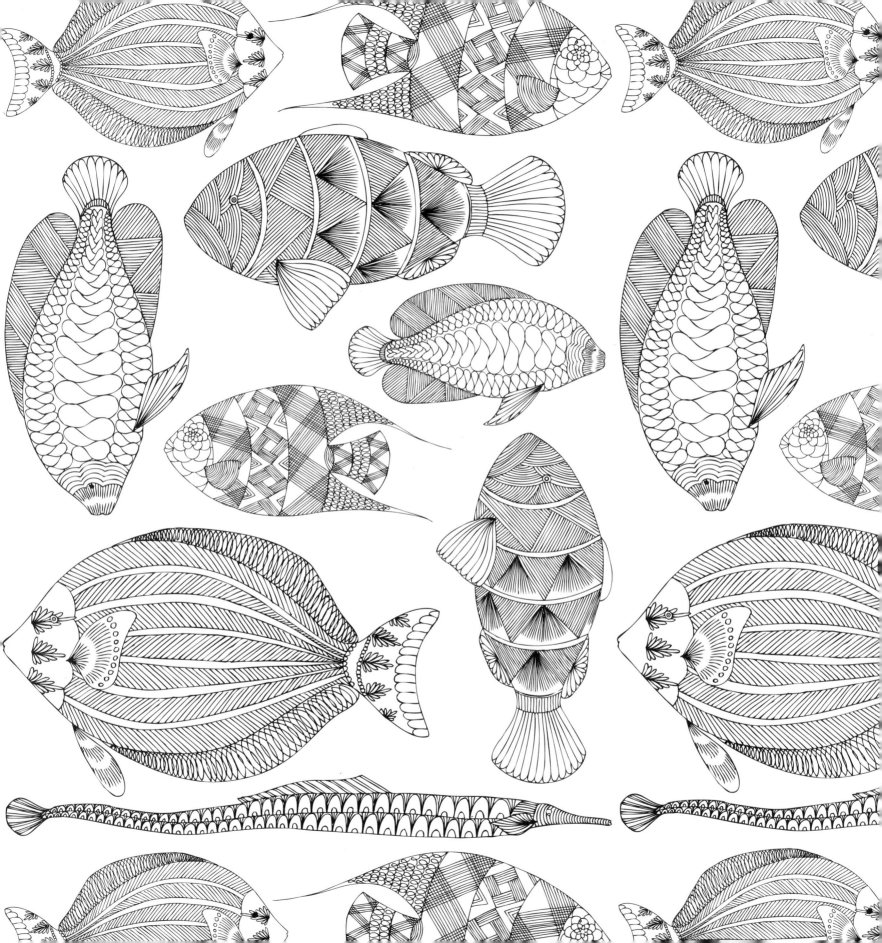

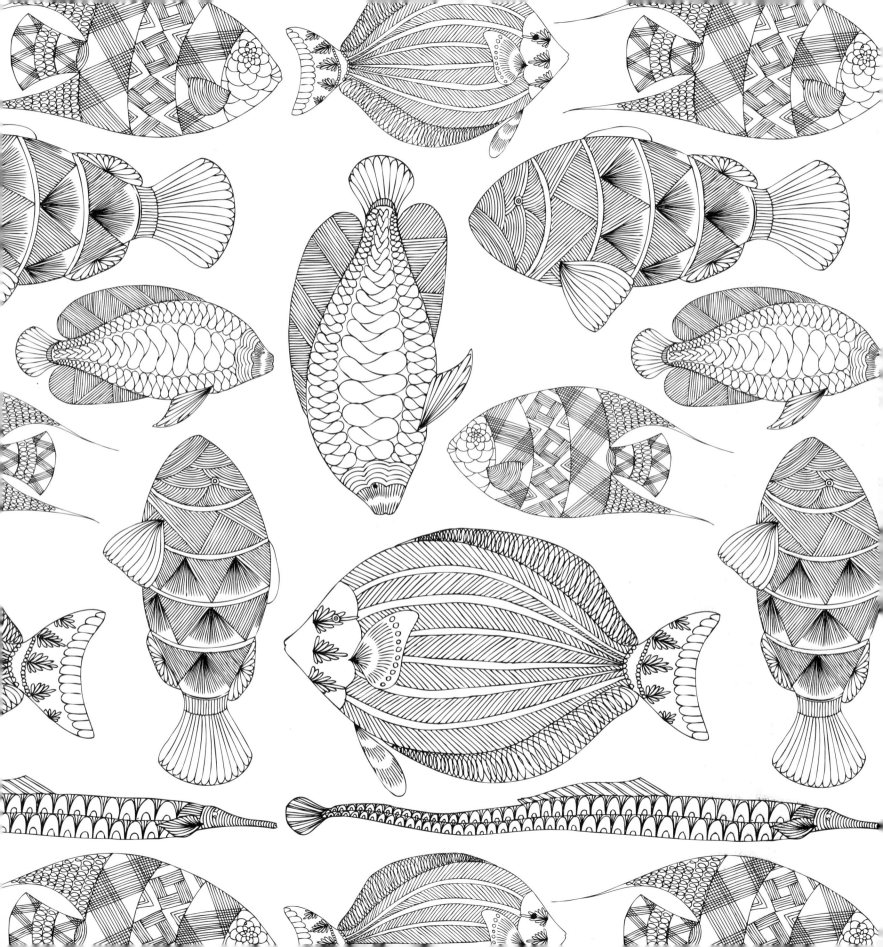

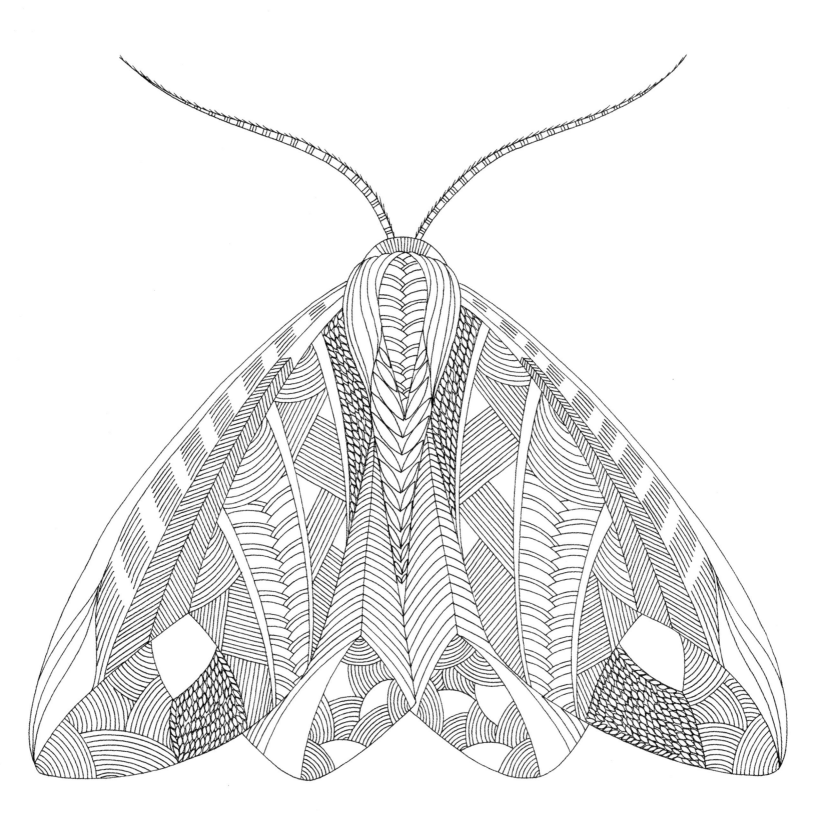

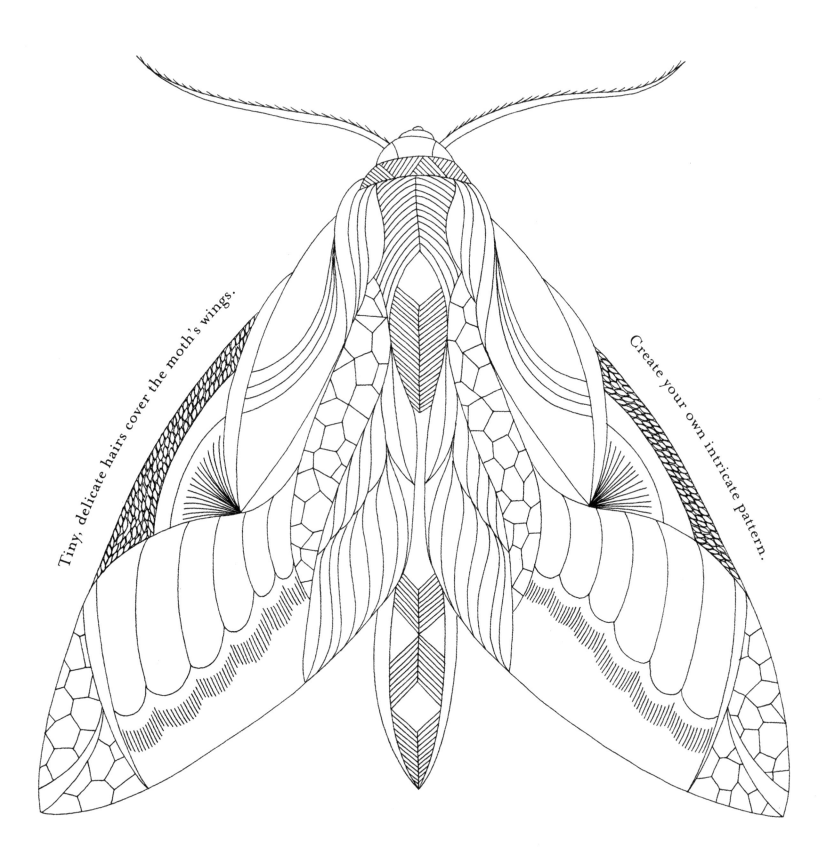

Tiny, delicate hairs cover the moth's wings.

Create your own intricate pattern.

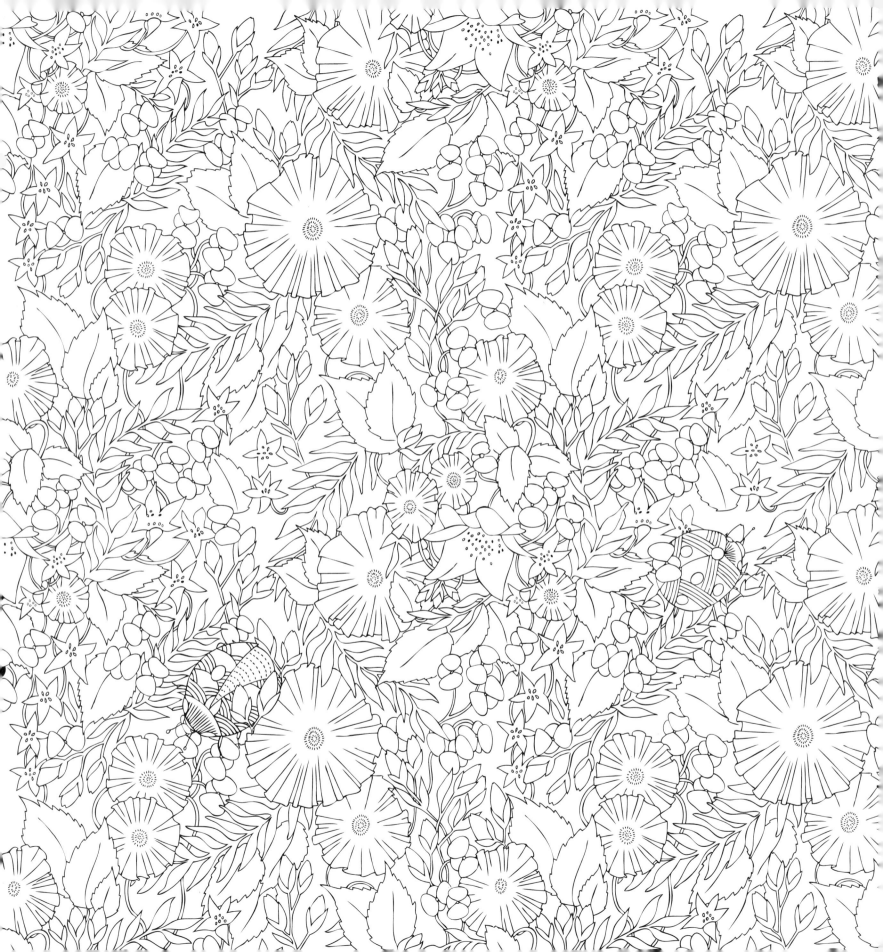

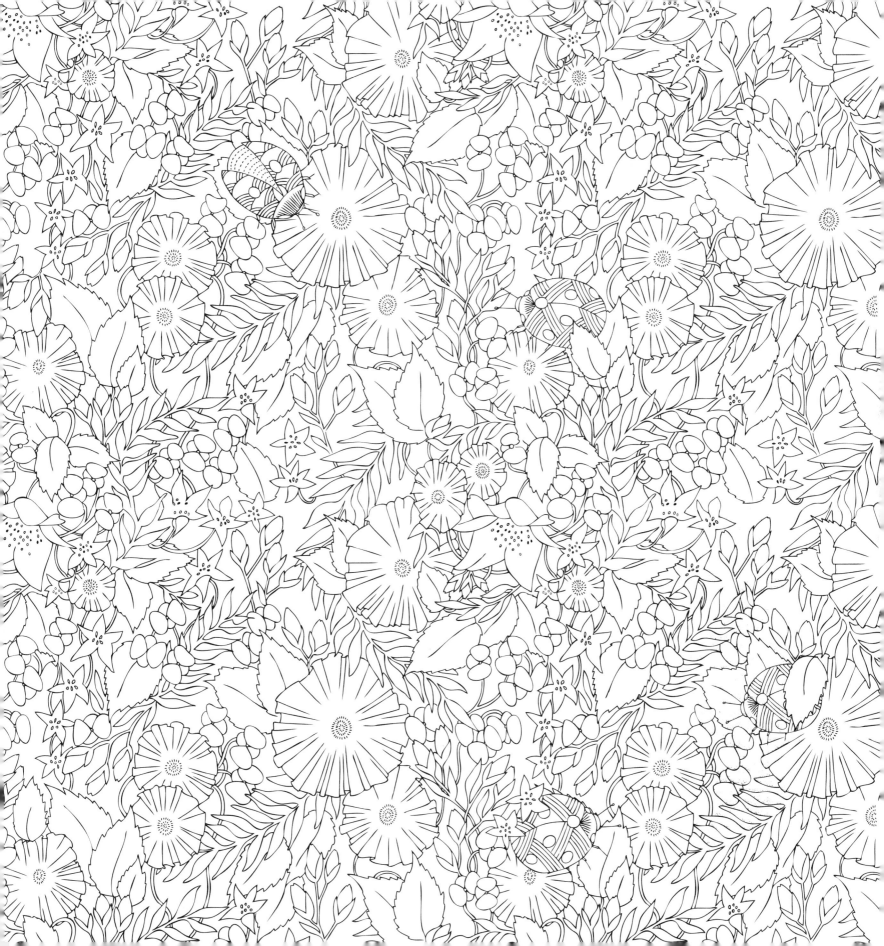

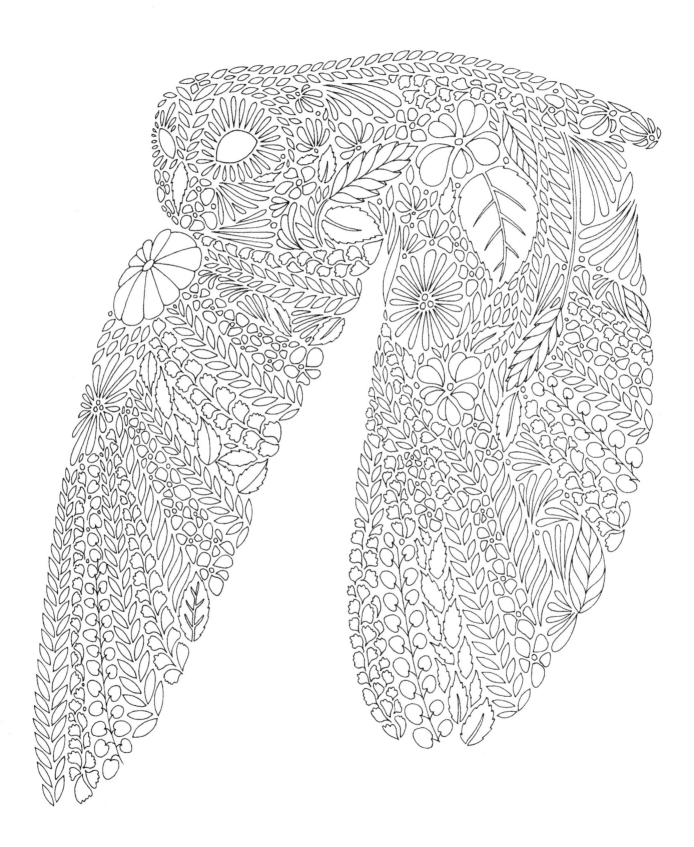

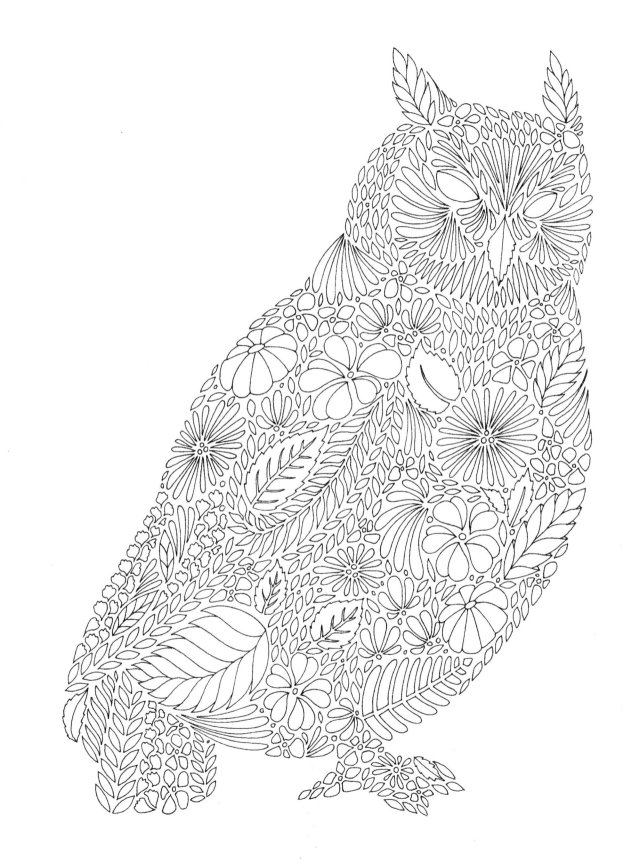

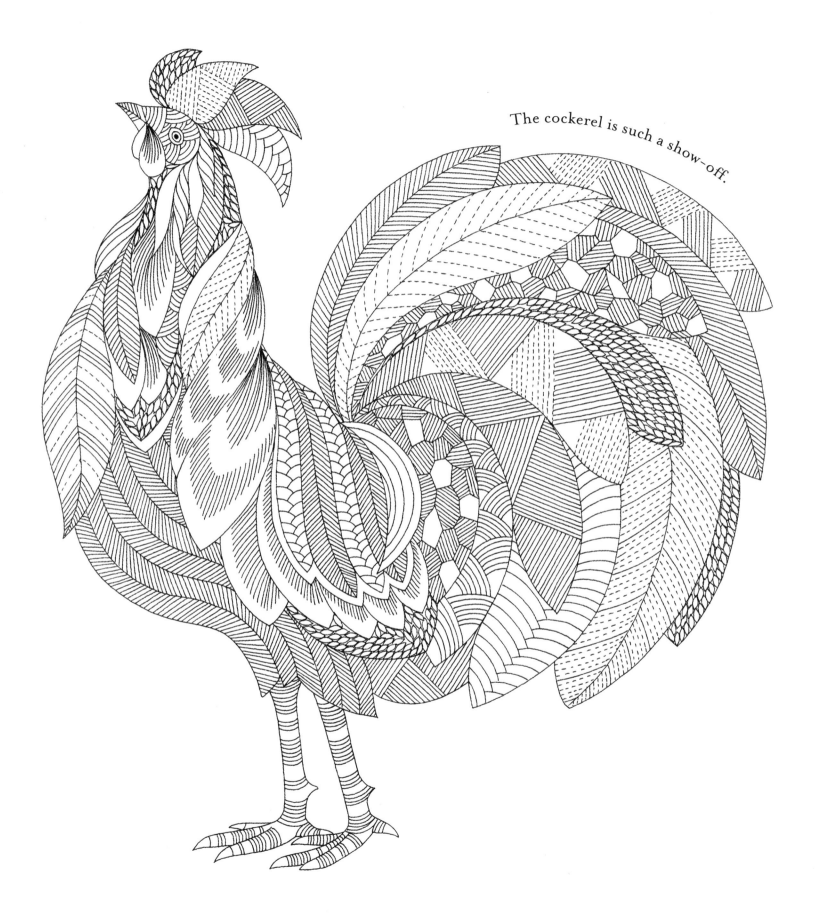

The cockerel is such a show-off.

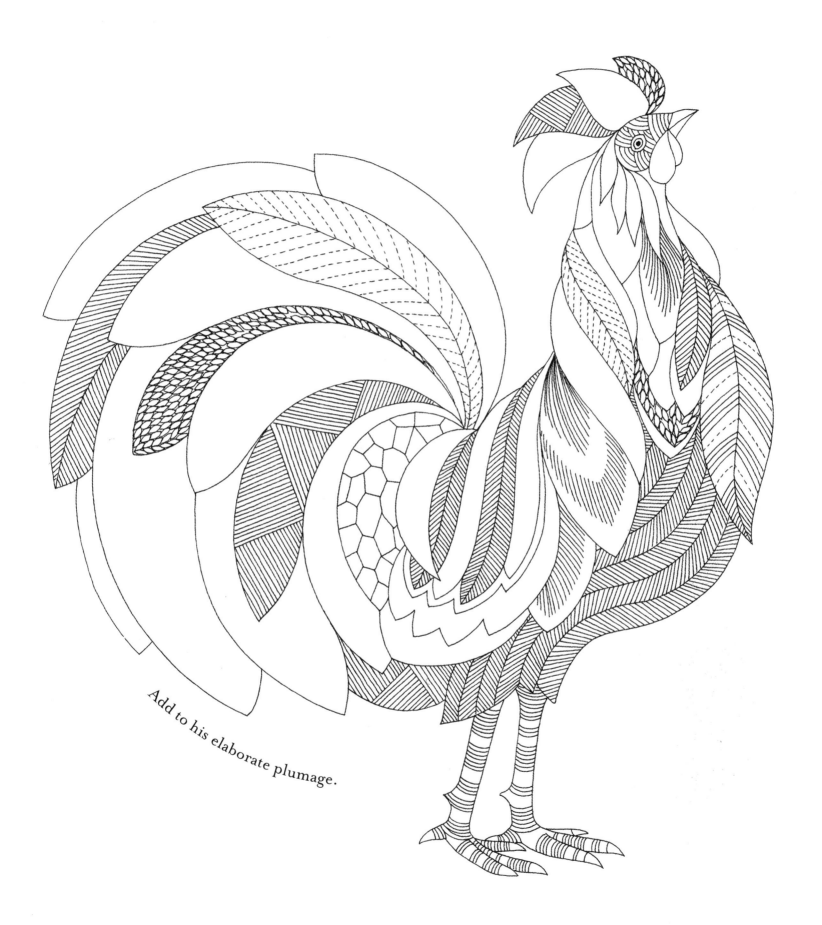

Add to his elaborate plumage.

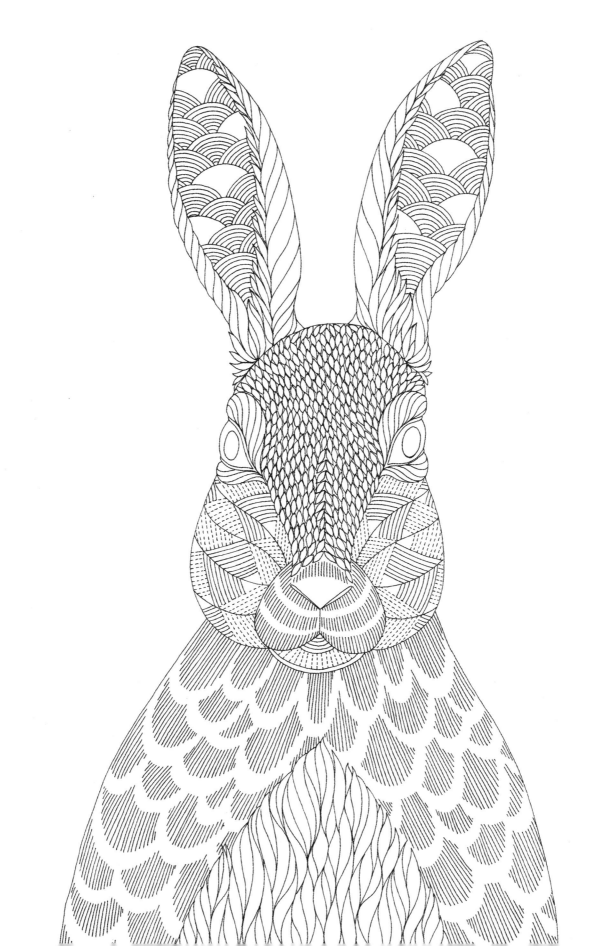

Slow and steady wins the race. Take your time decorating the tortoise's shell.

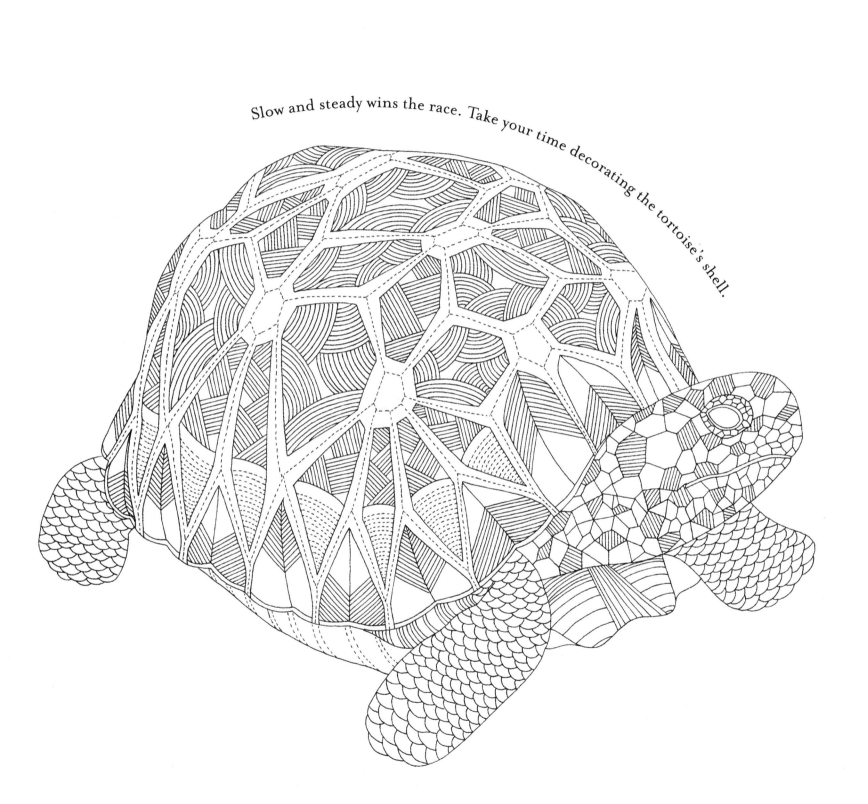

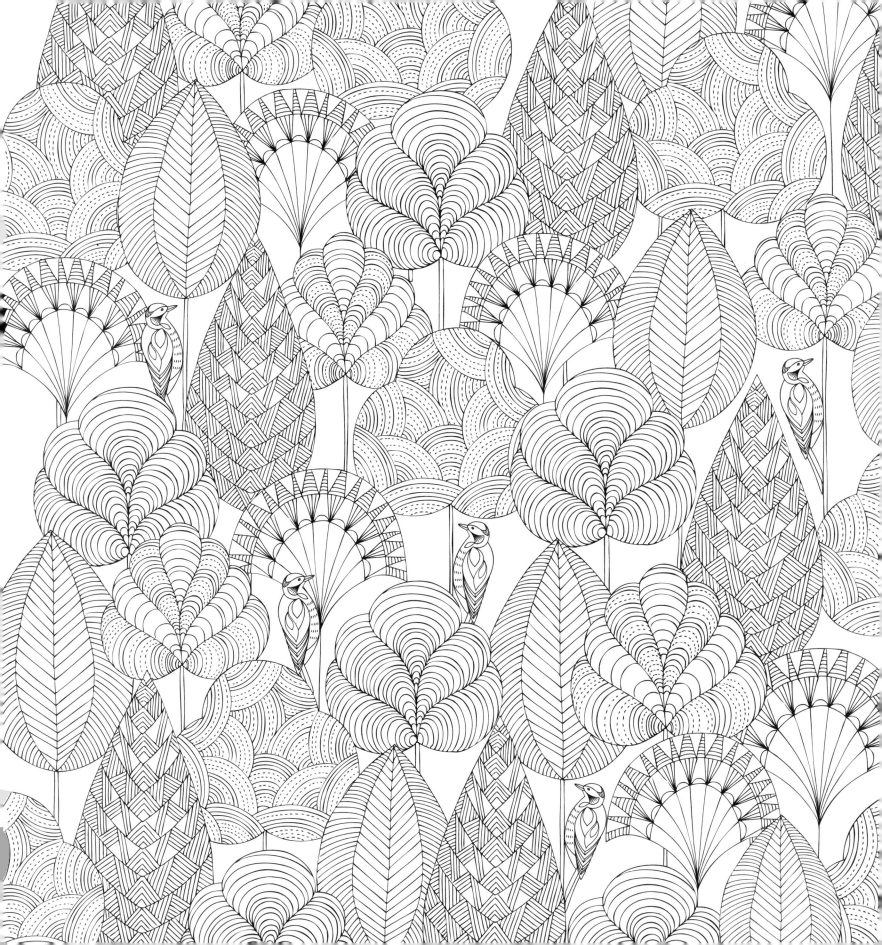

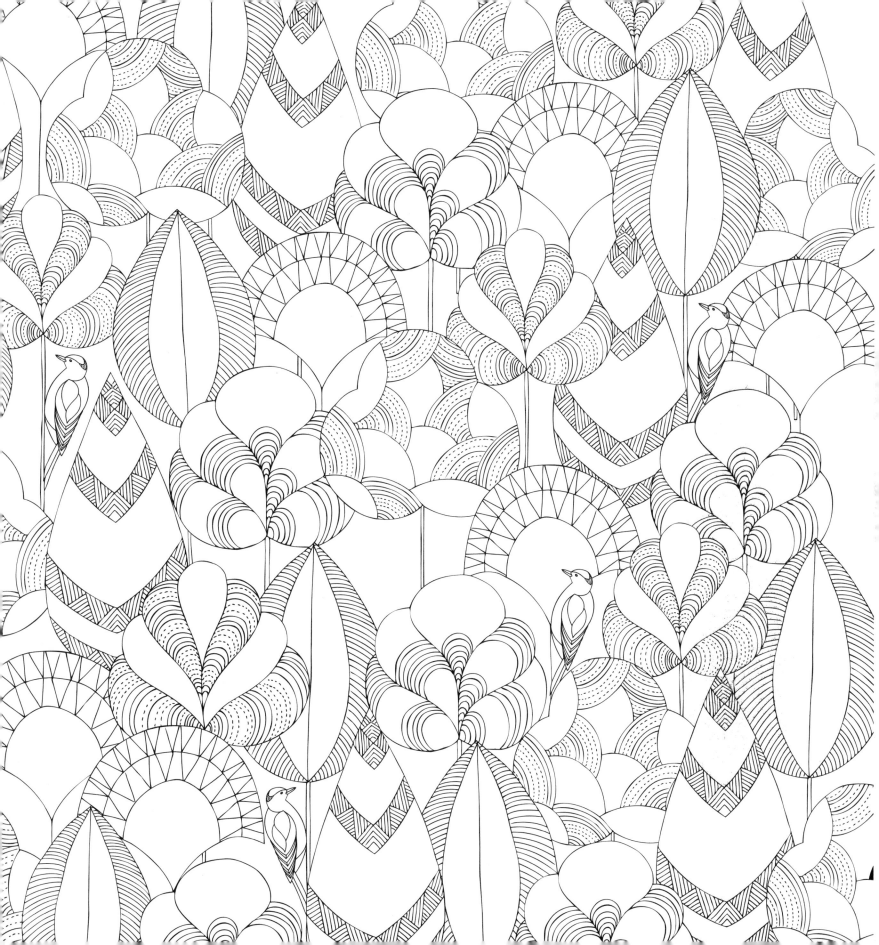

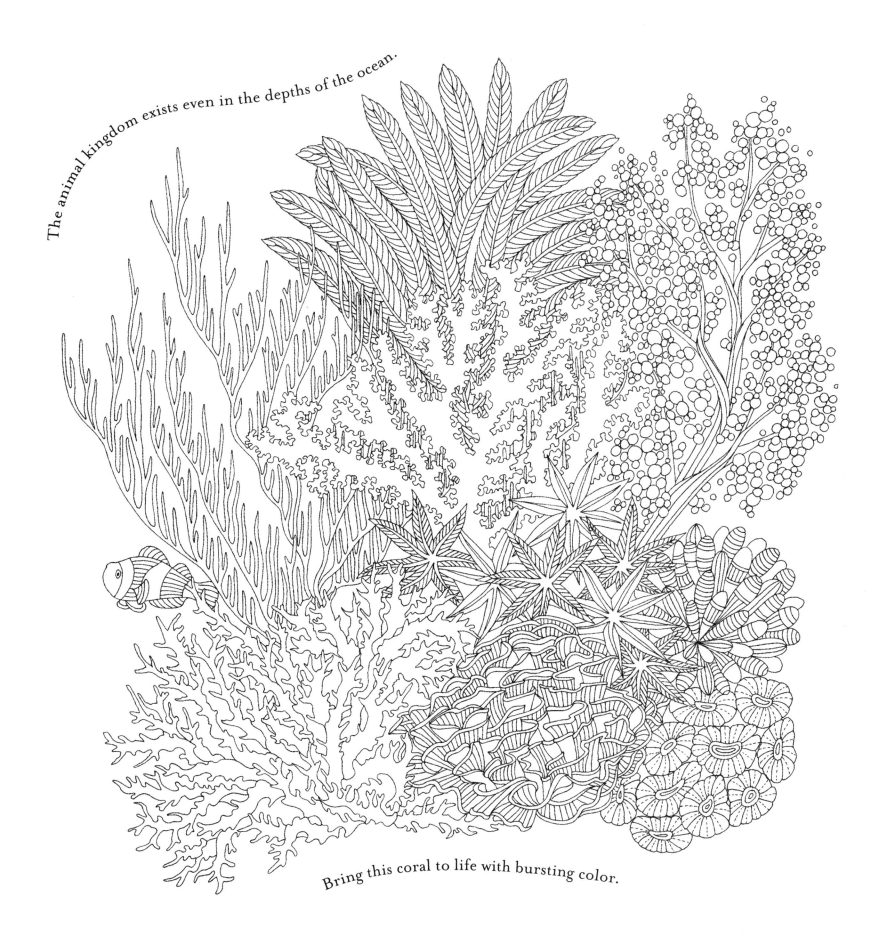

The animal kingdom exists even in the depths of the ocean.

Bring this coral to life with bursting color.

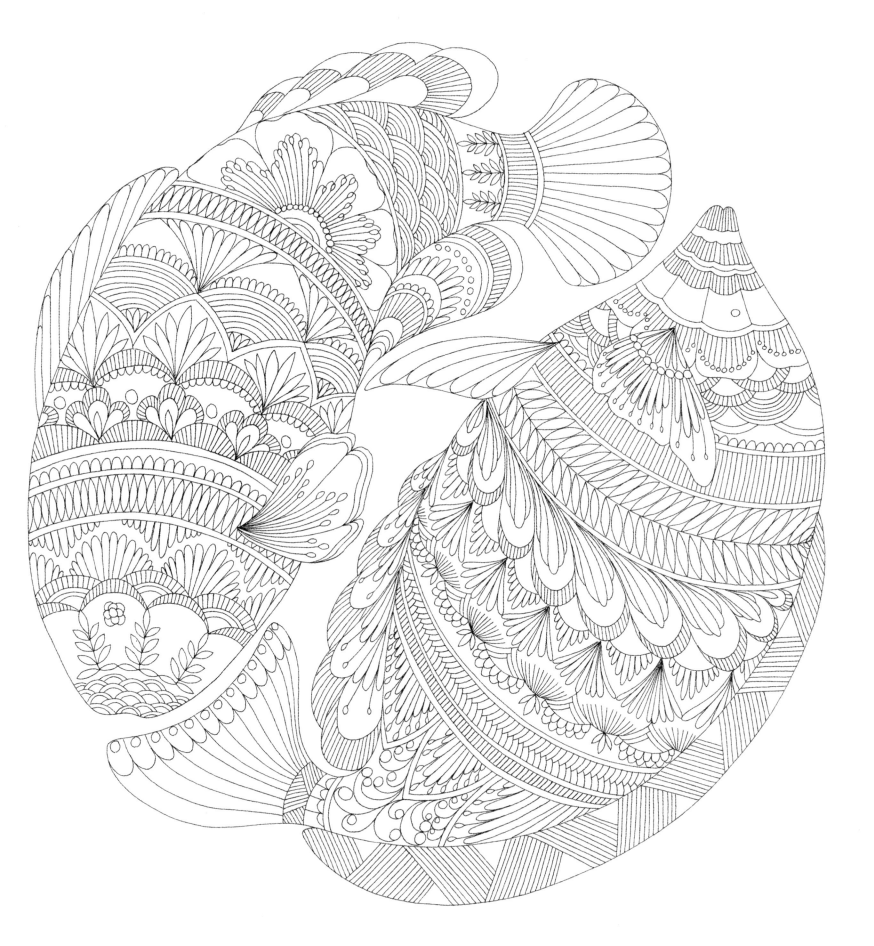

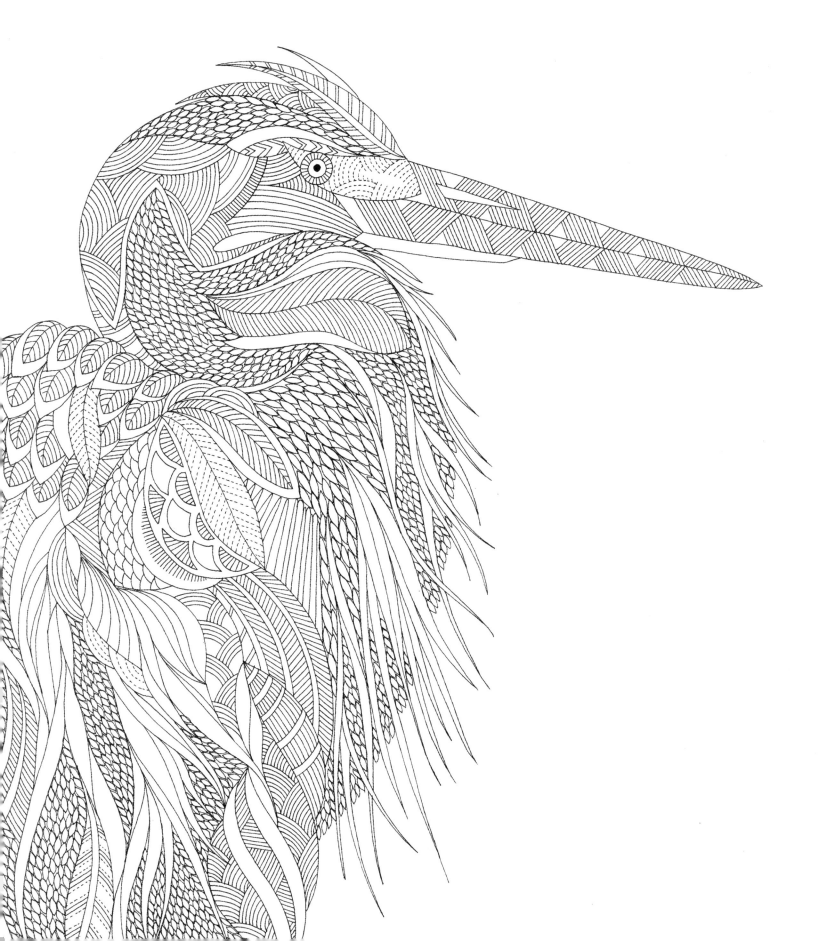

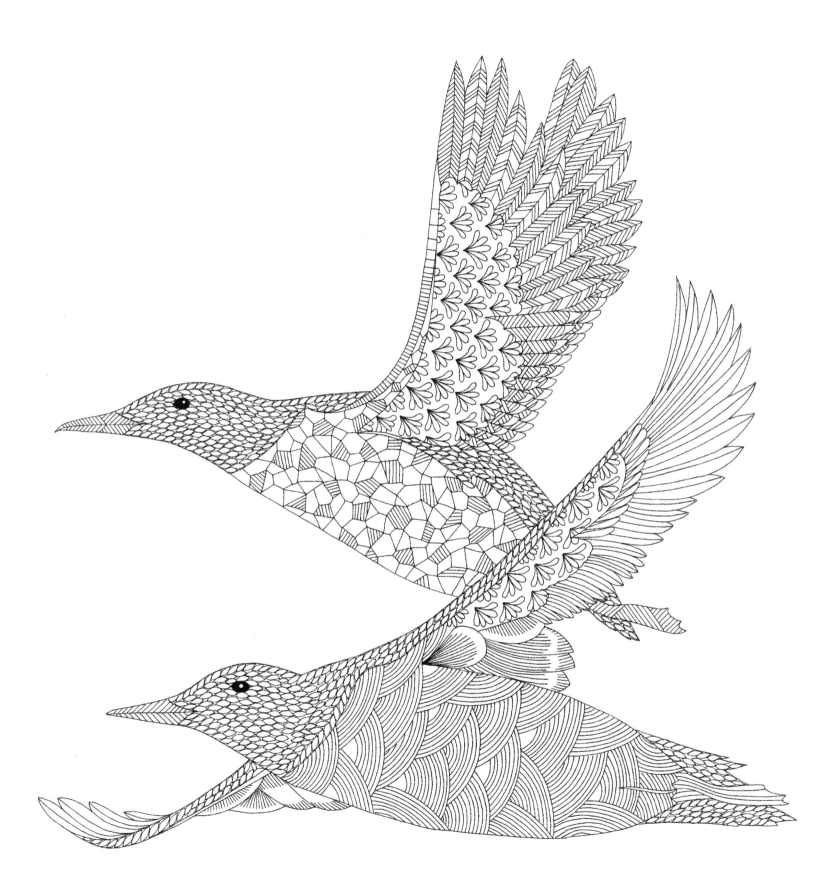

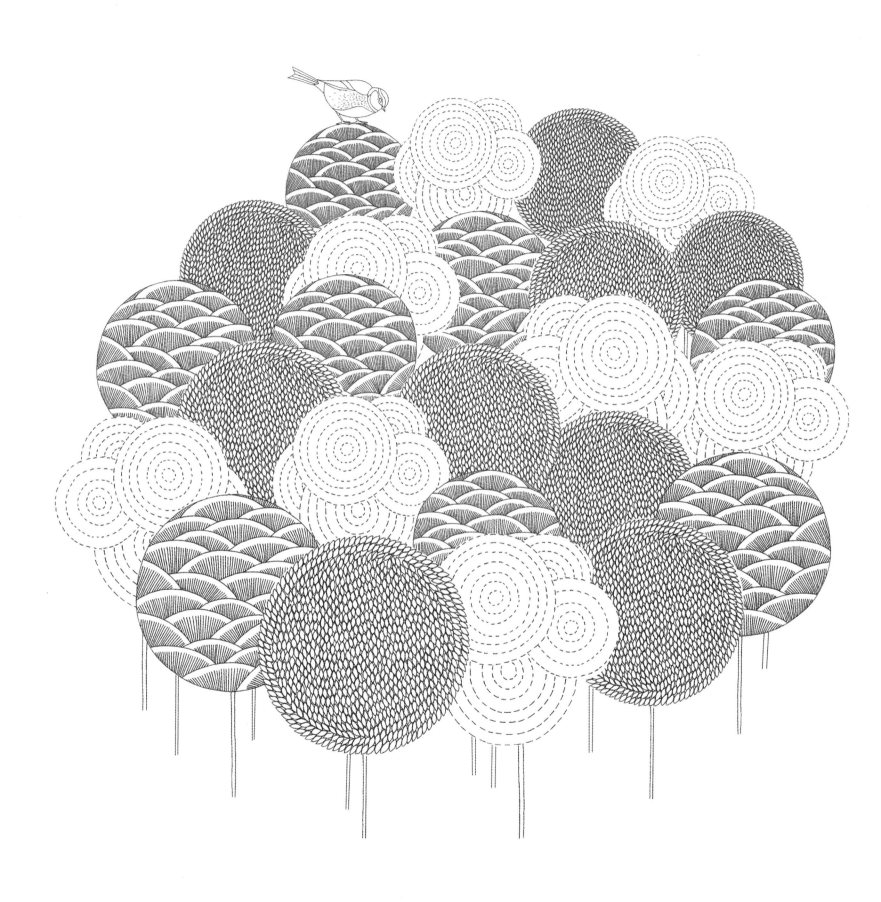

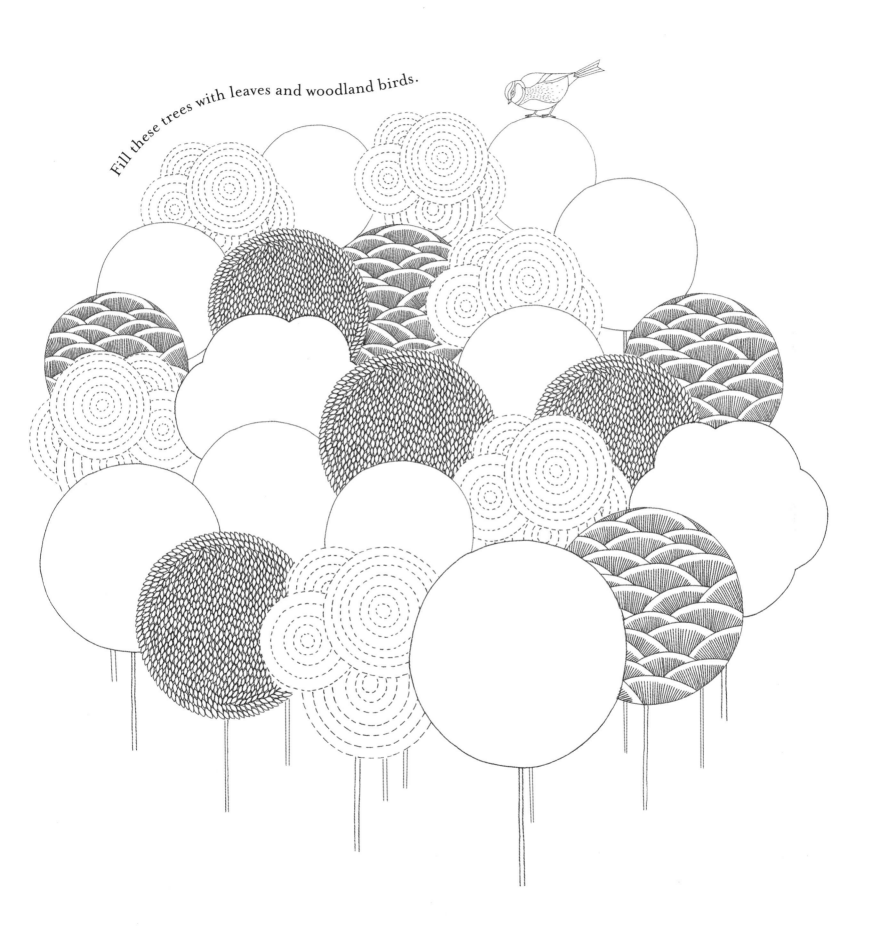

Fill these trees with leaves and woodland birds.

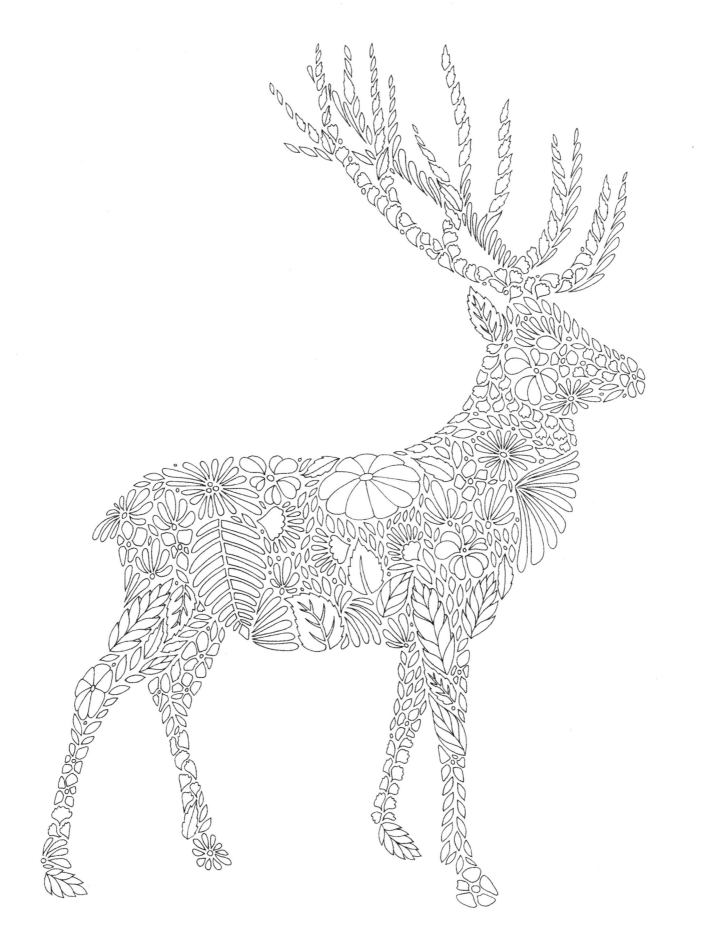

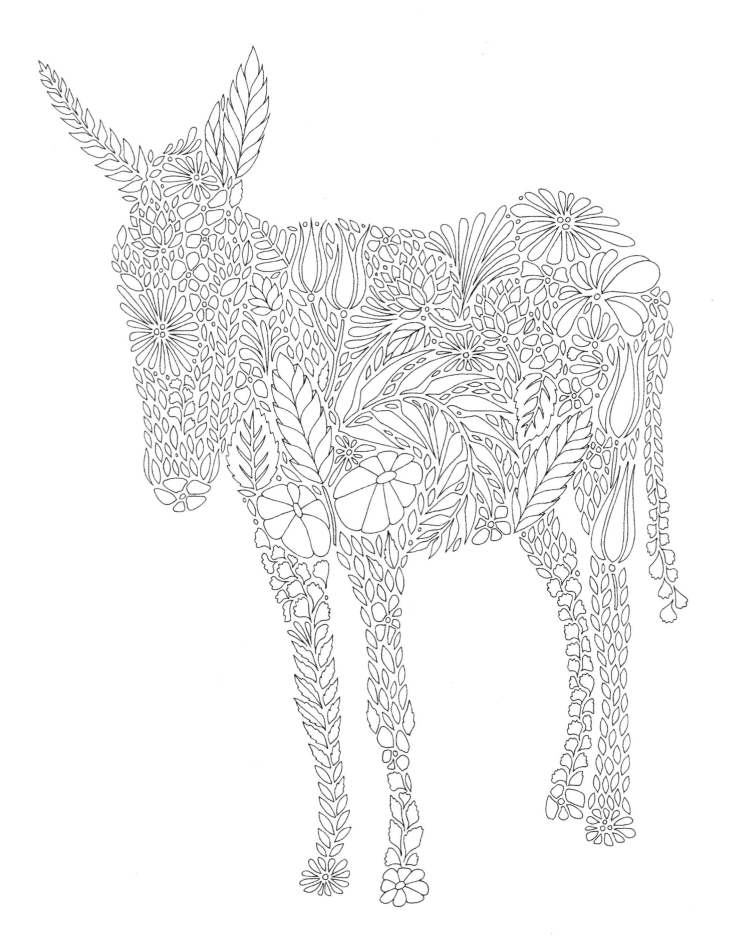

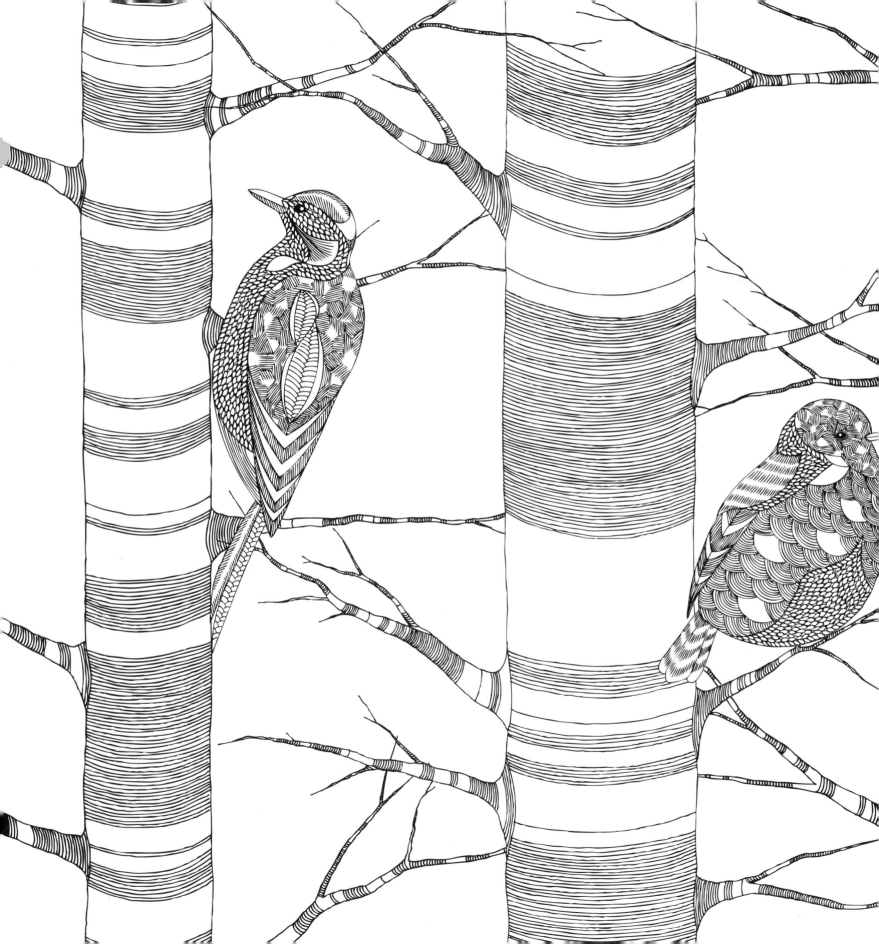

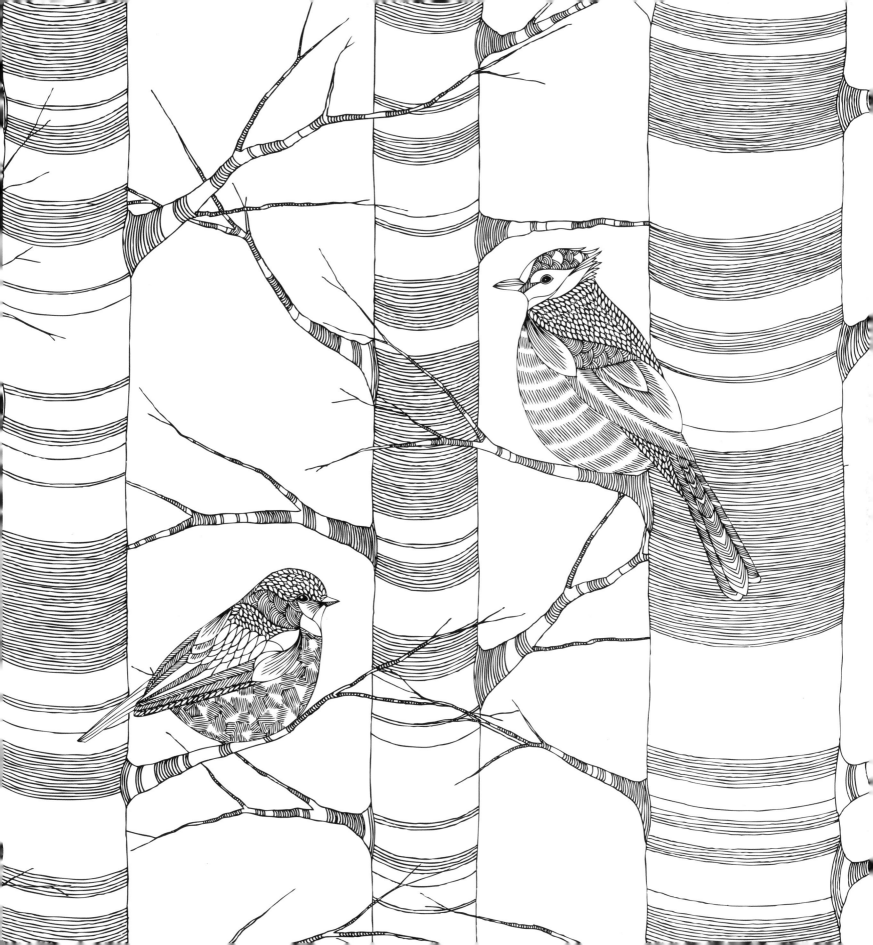

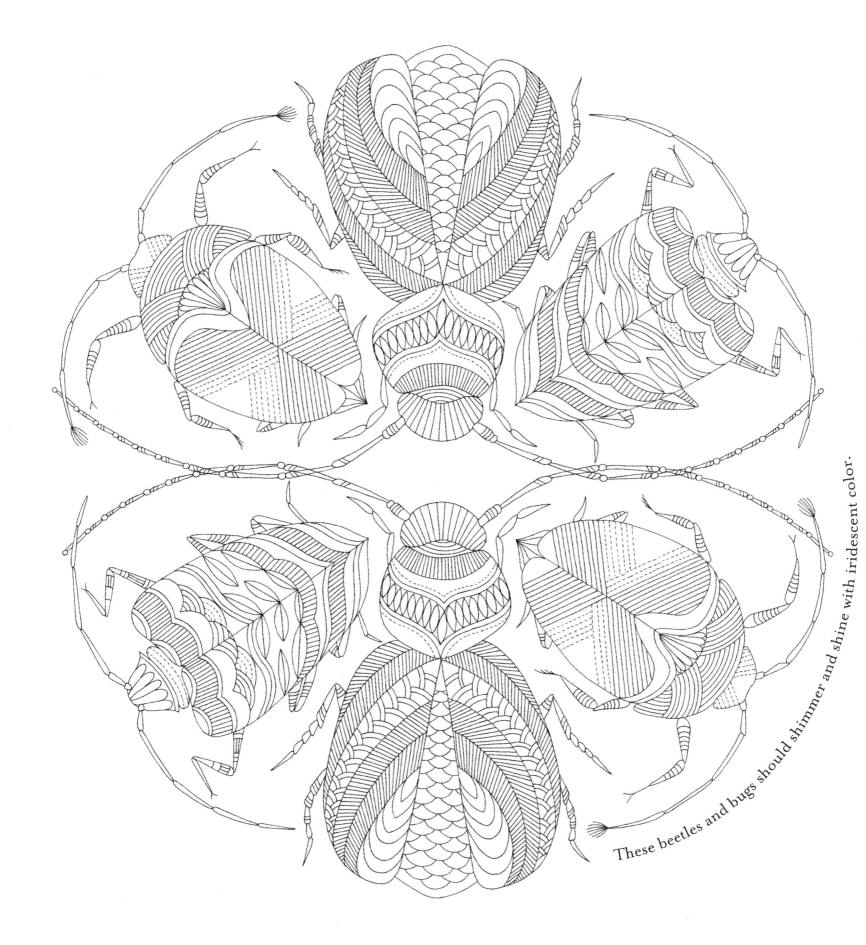

These beetles and bugs should shimmer and shine with iridescent color.

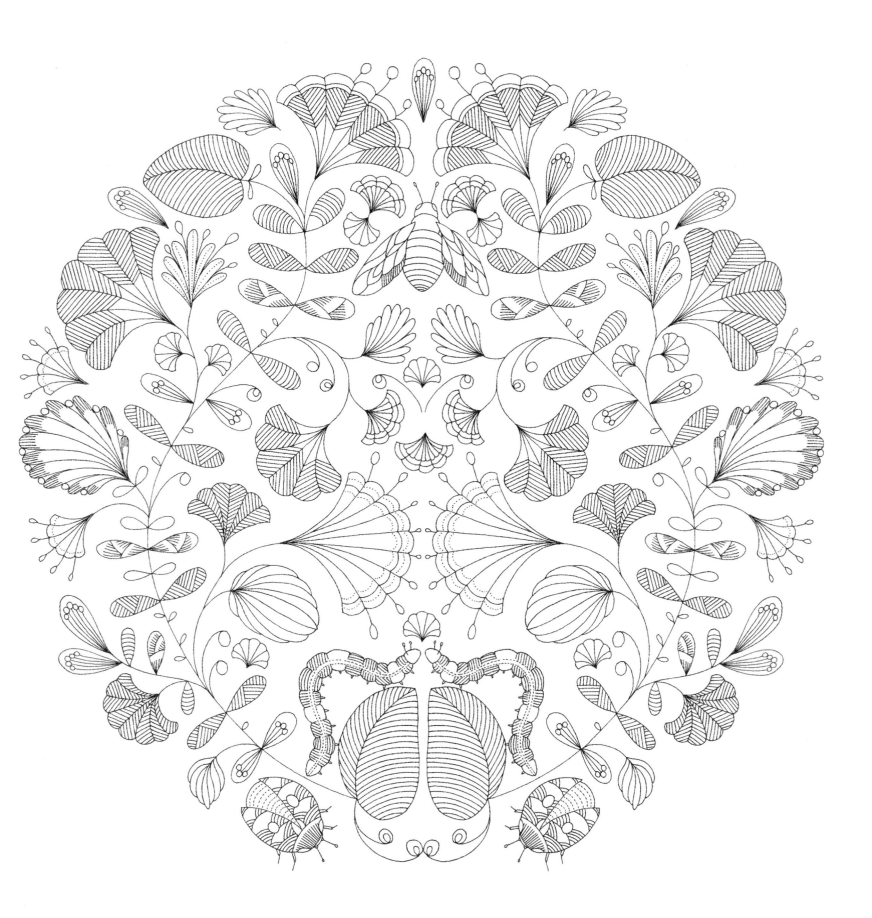

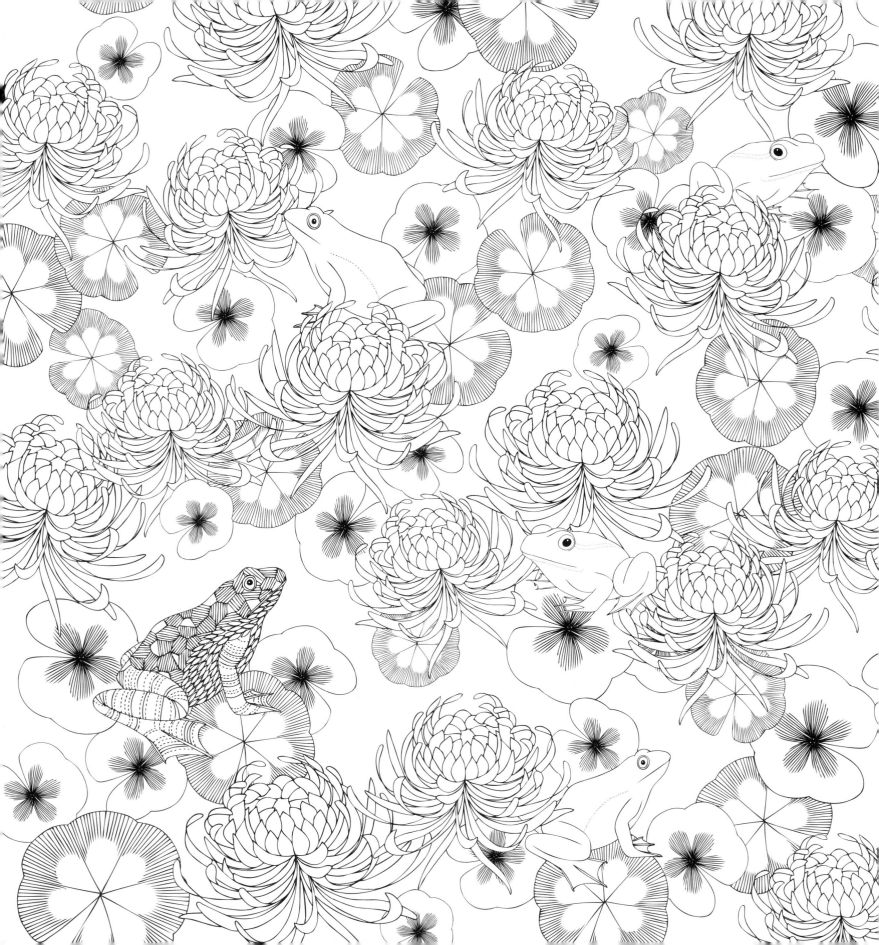

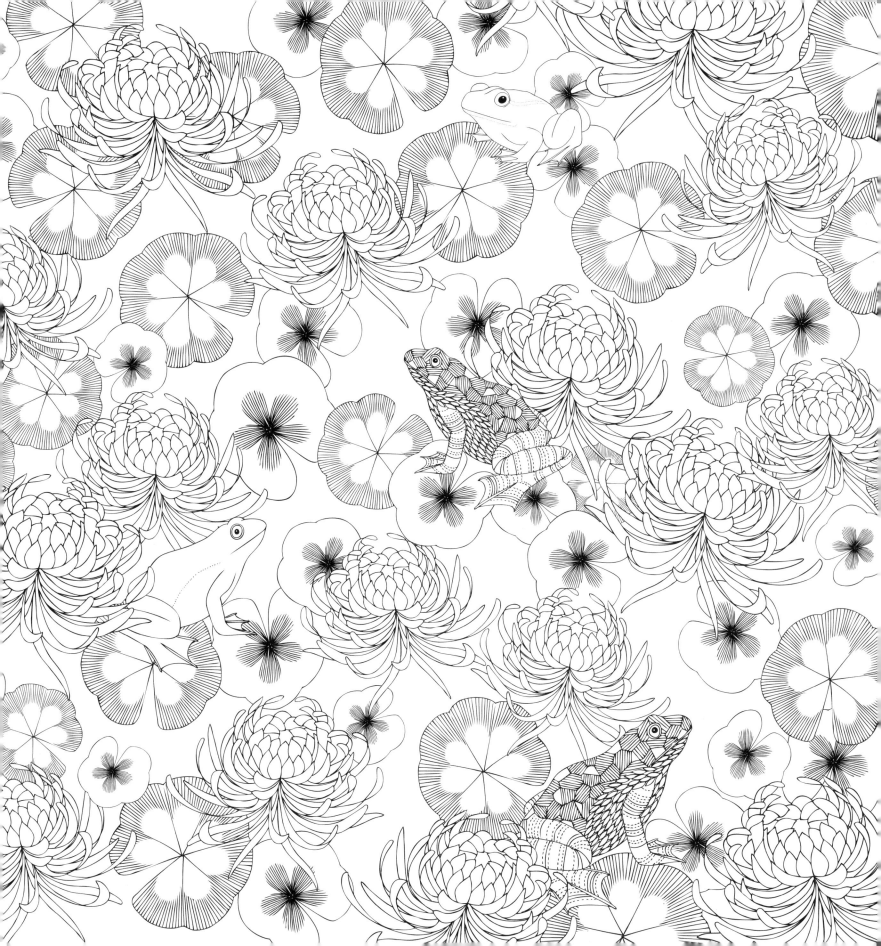

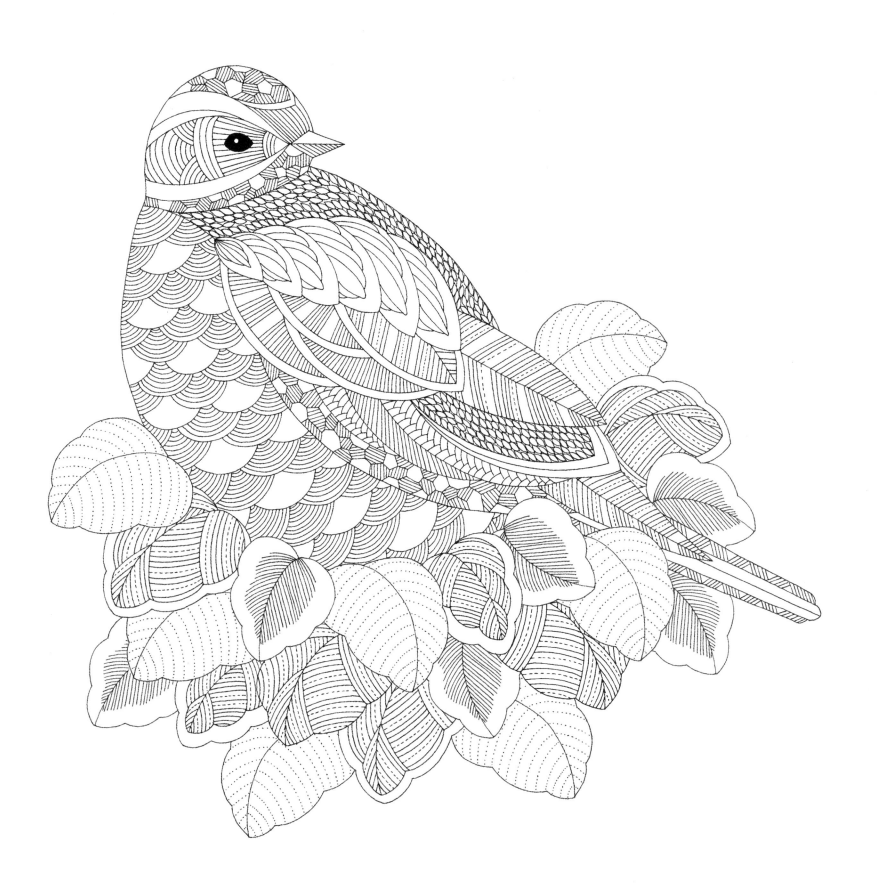

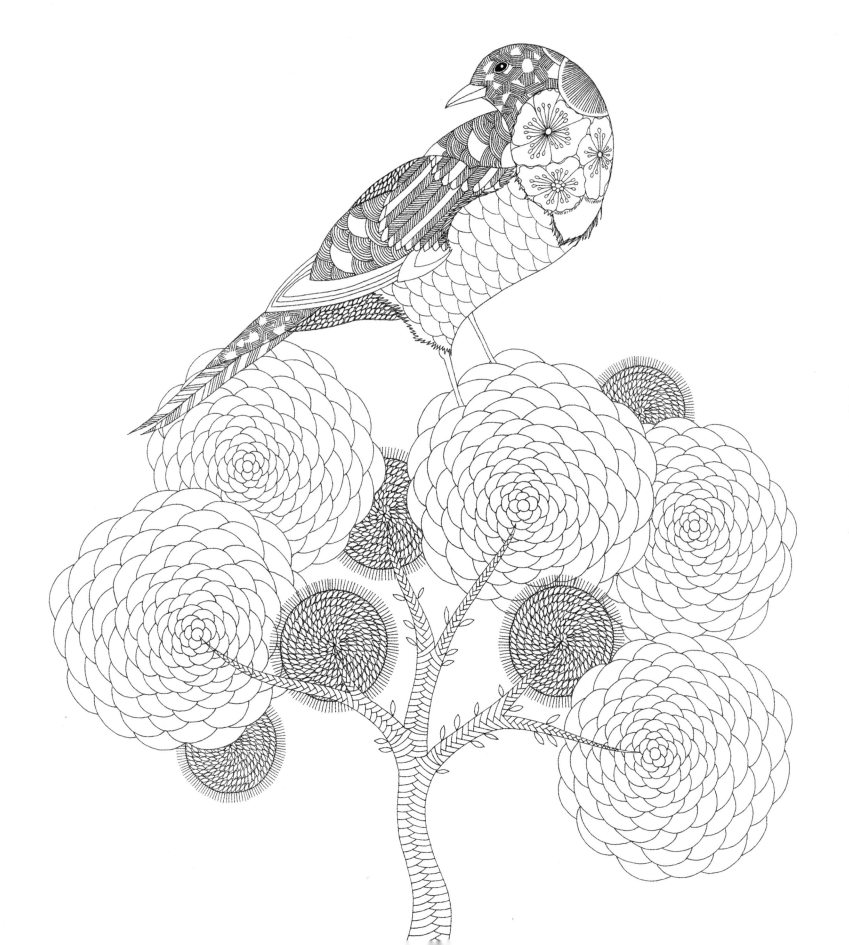

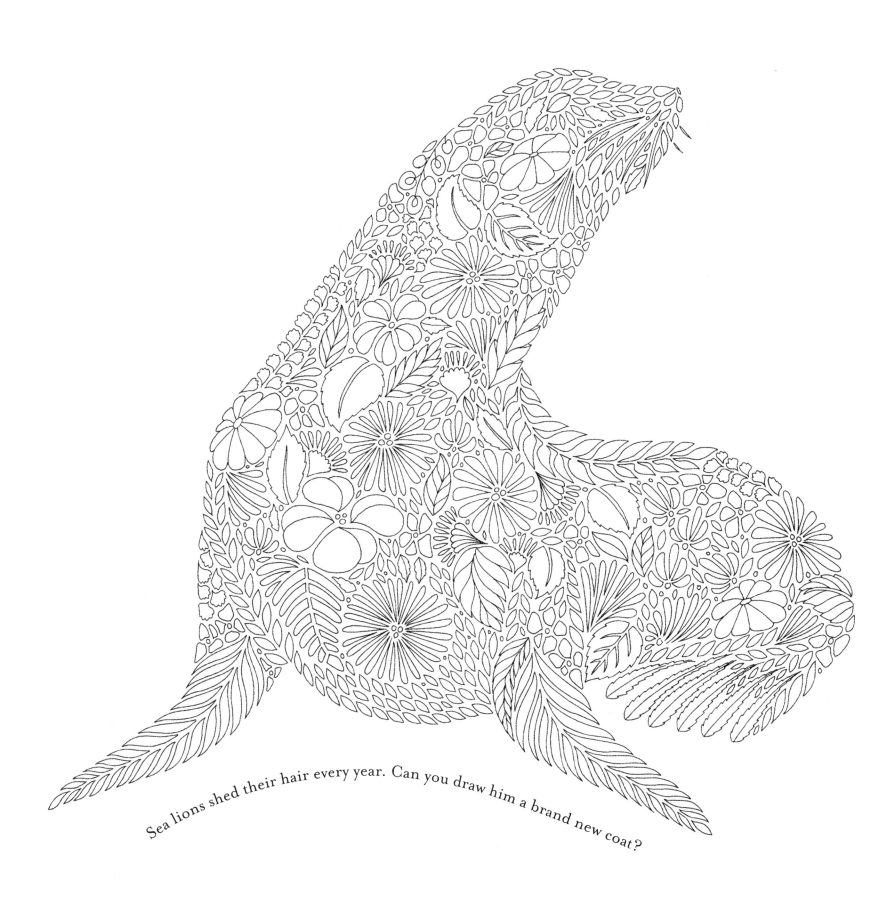

Sea lions shed their hair every year. Can you draw him a brand new coat?

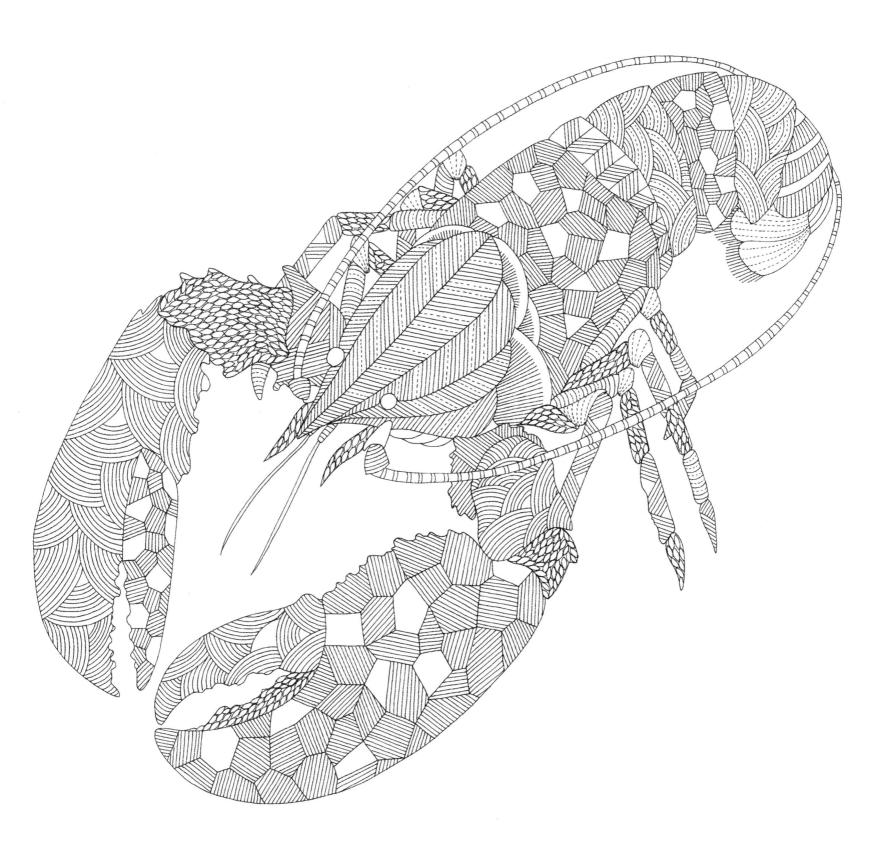

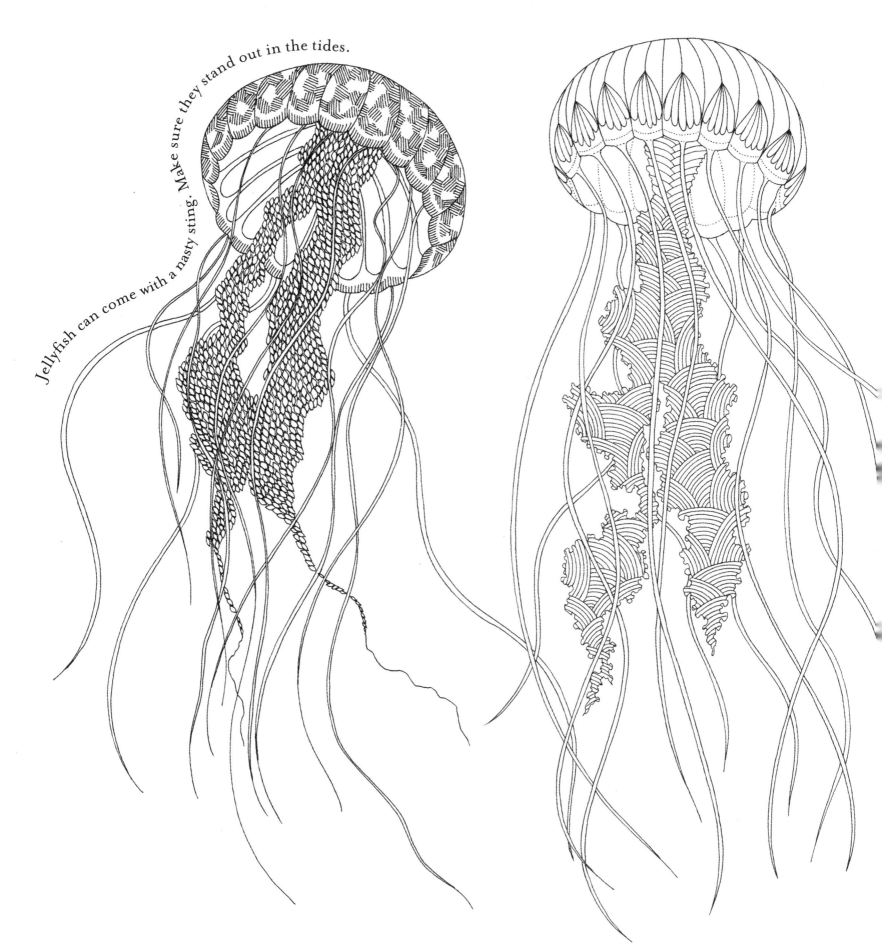

Jellyfish can come with a nasty sting. Make sure they stand out in the tides.

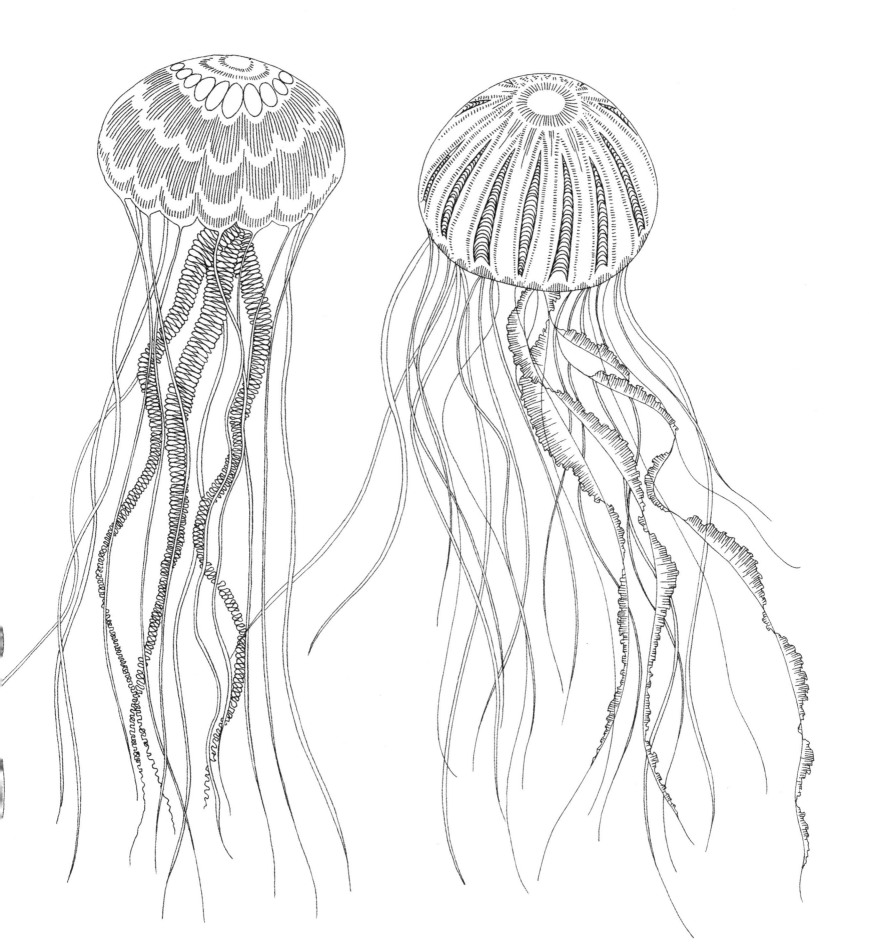

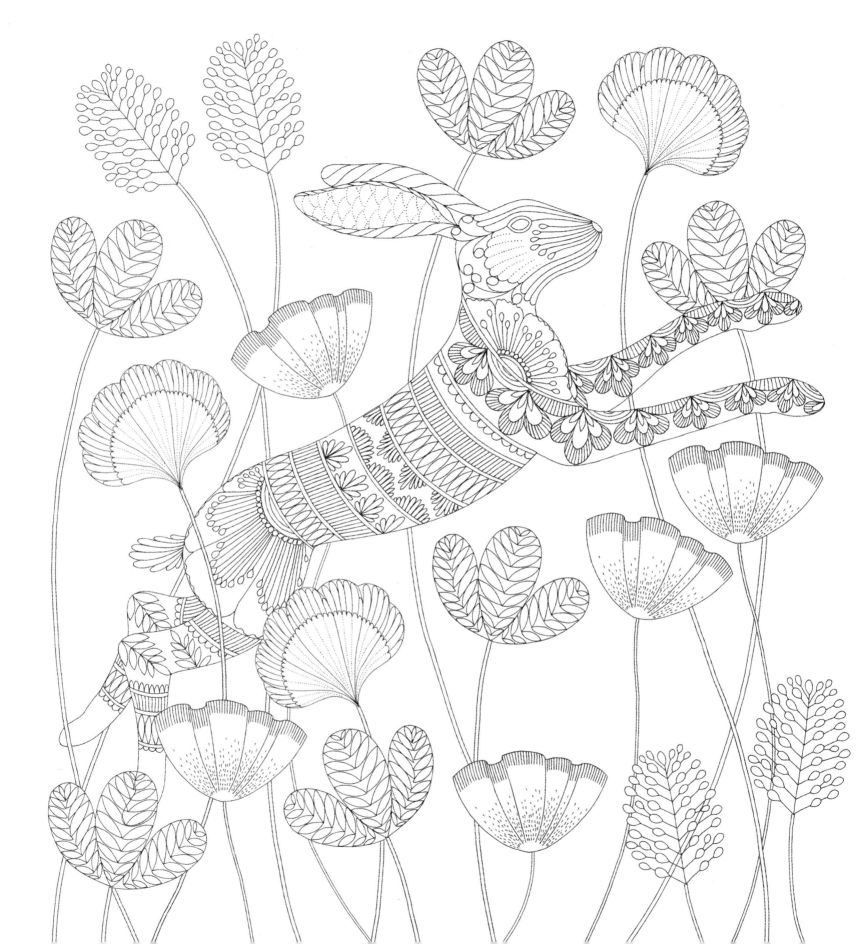

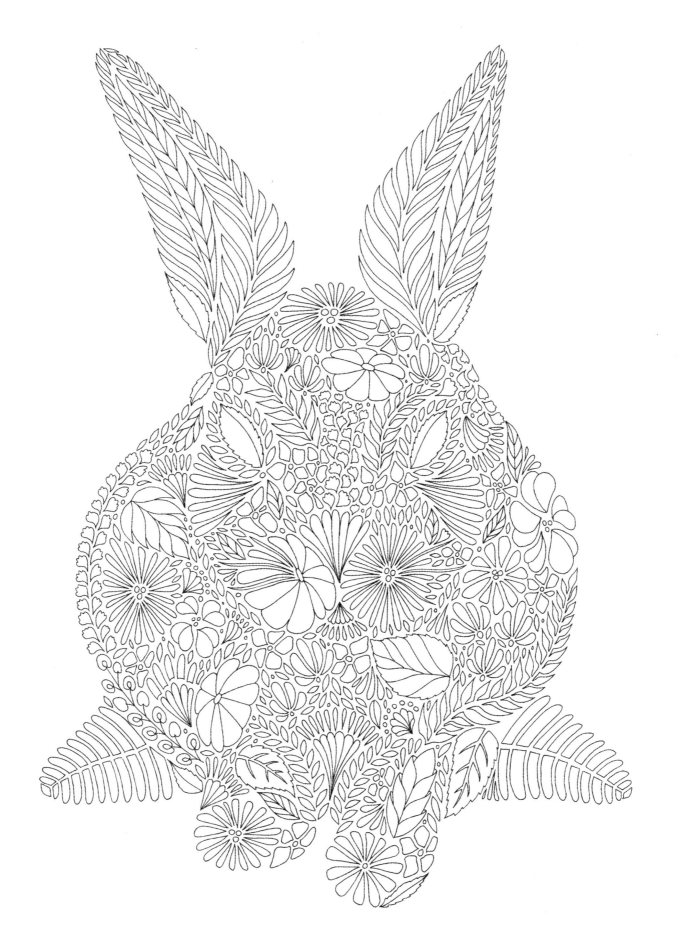

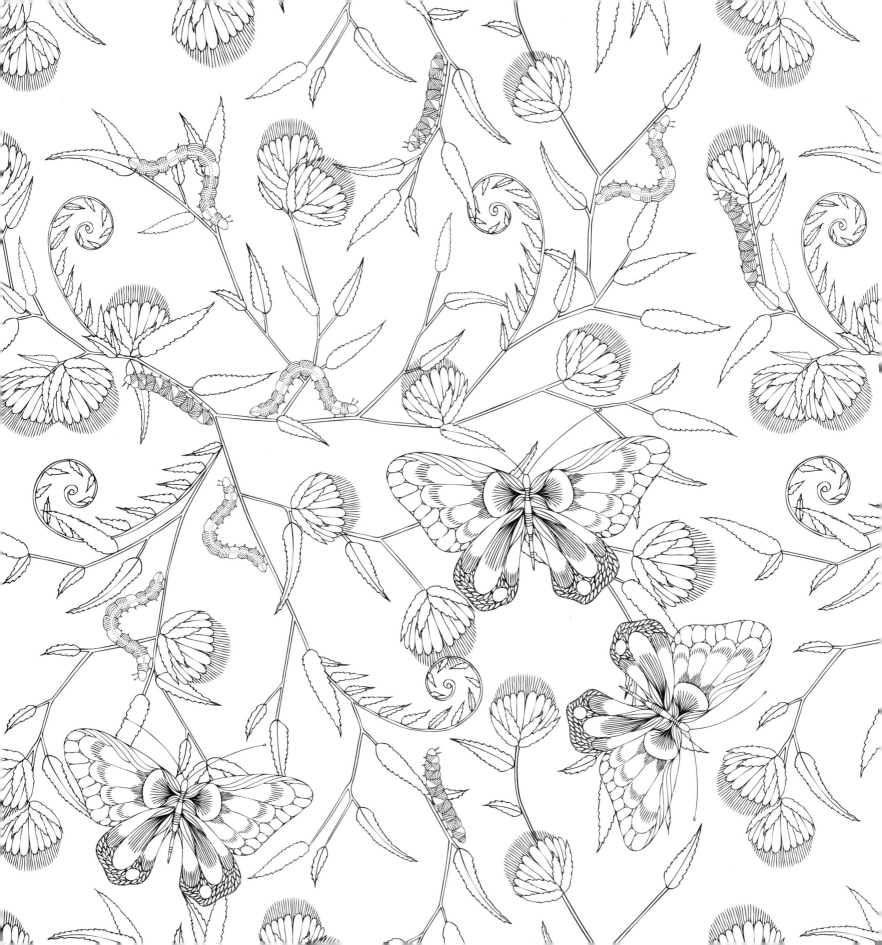

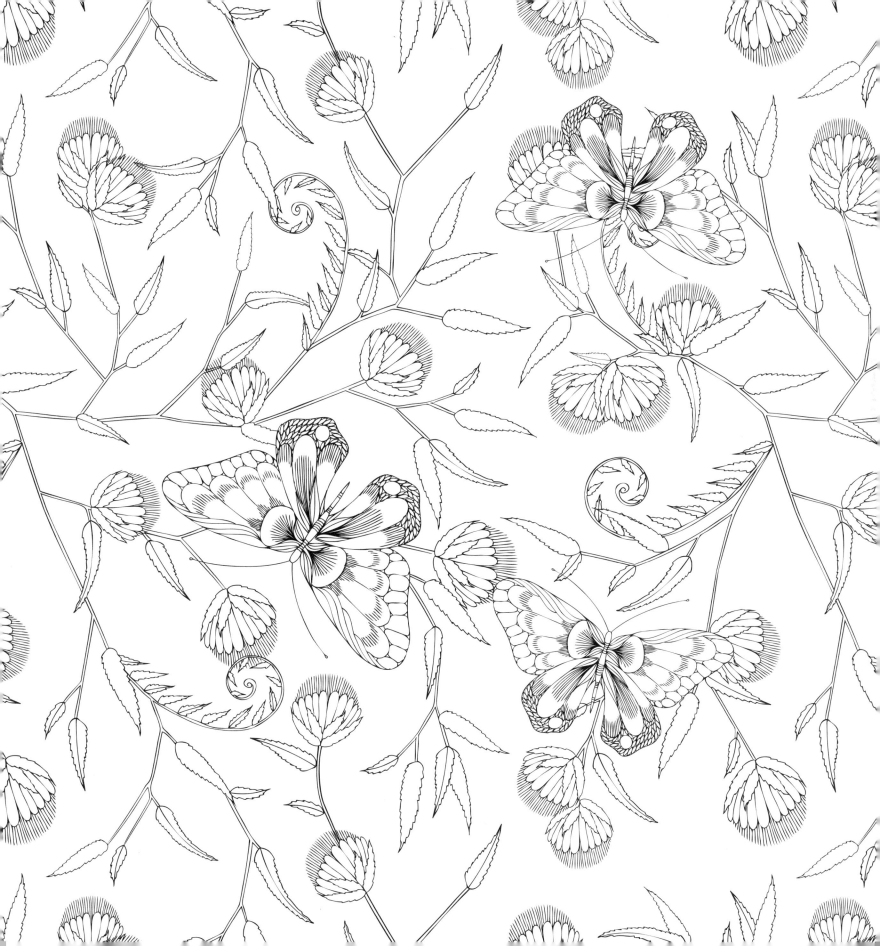

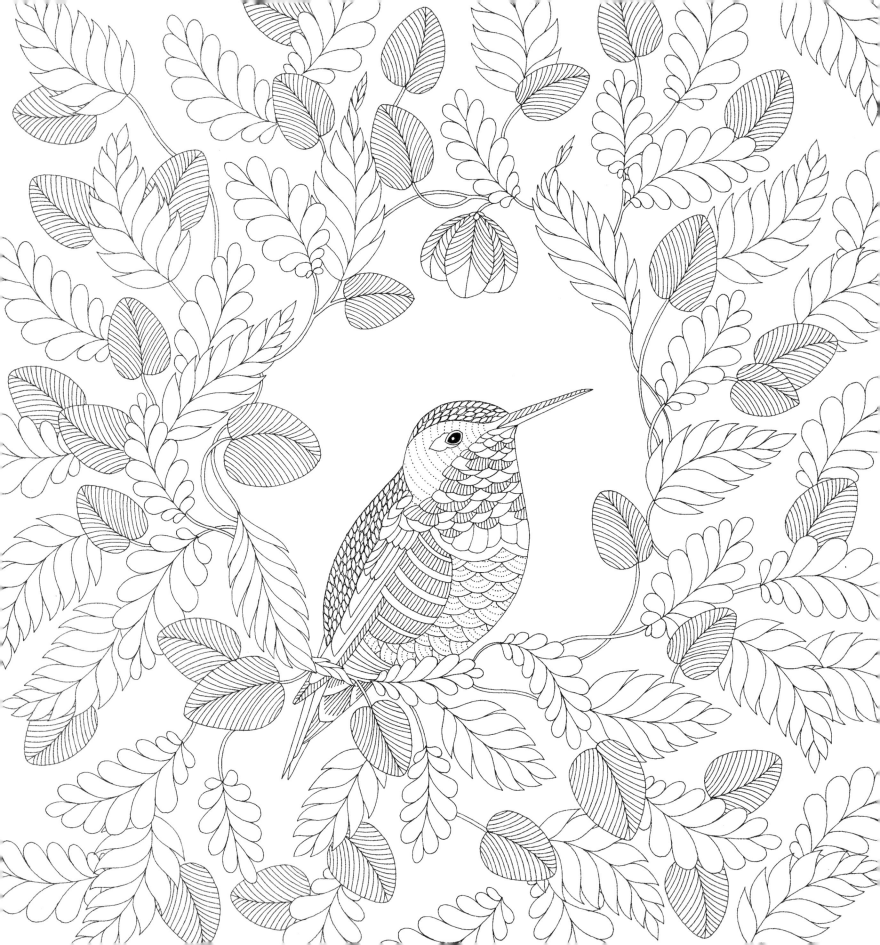

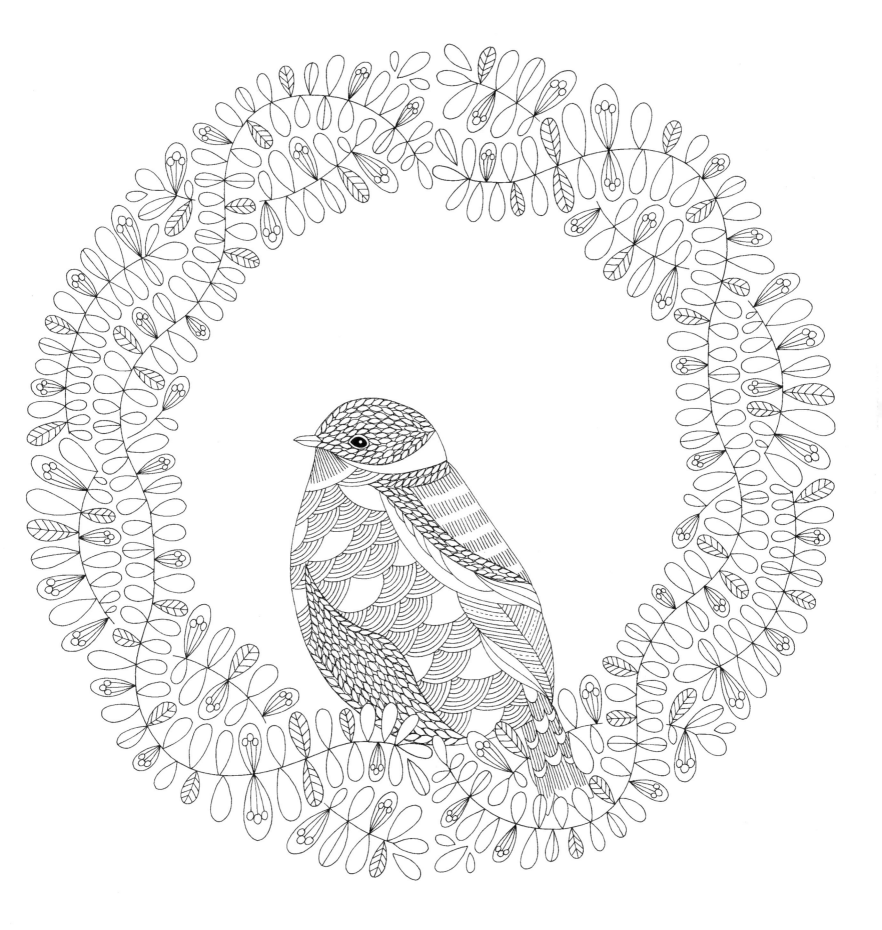

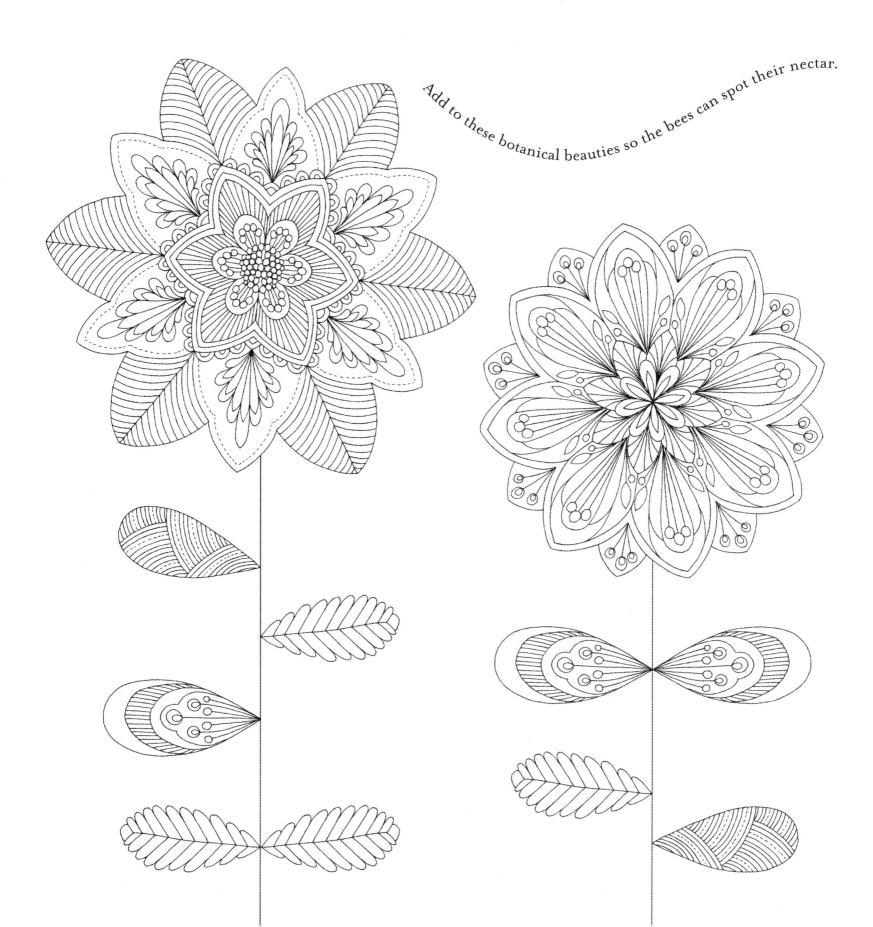

Add to these botanical beauties so the bees can spot their nectar.

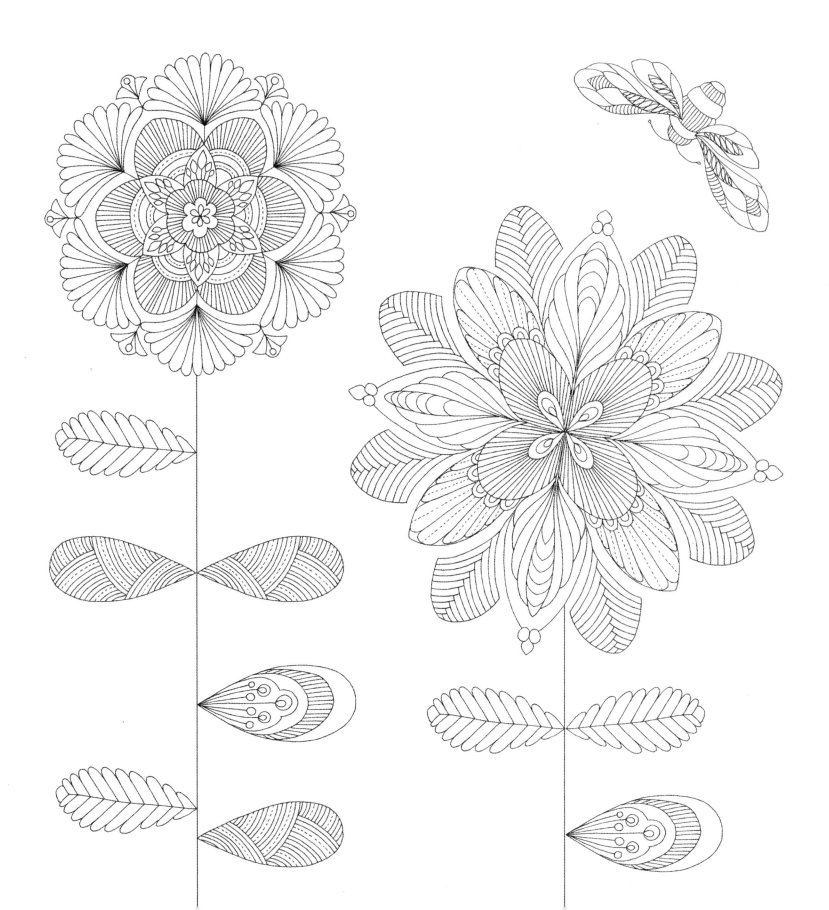

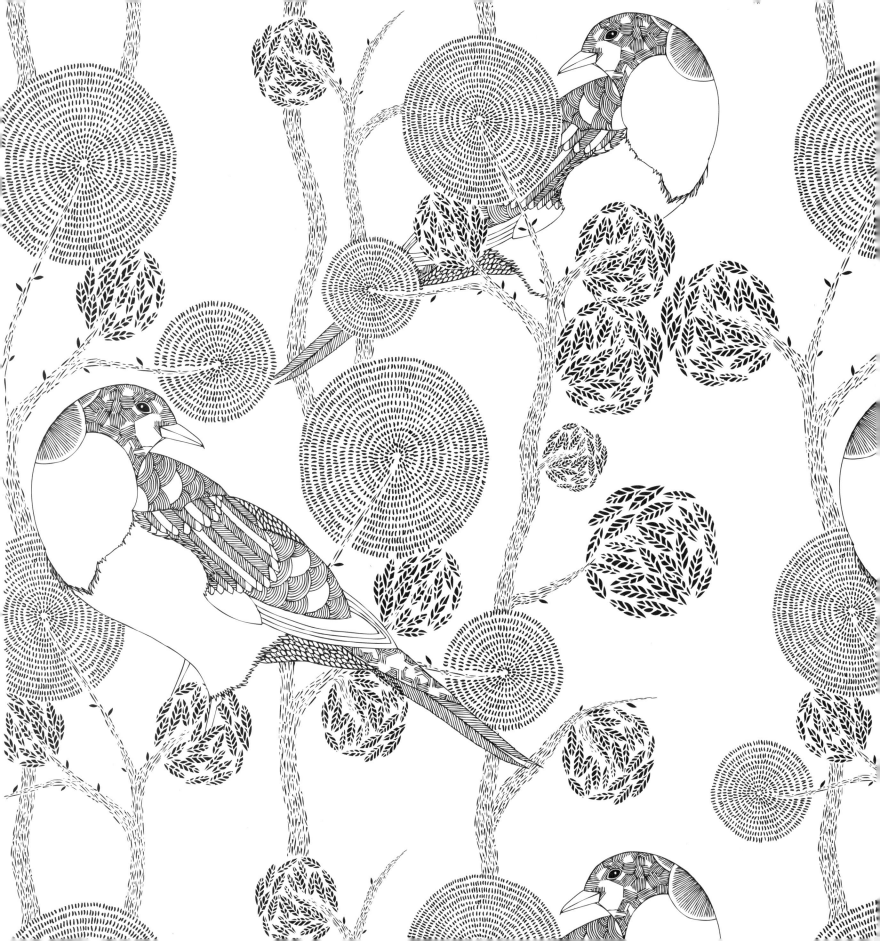

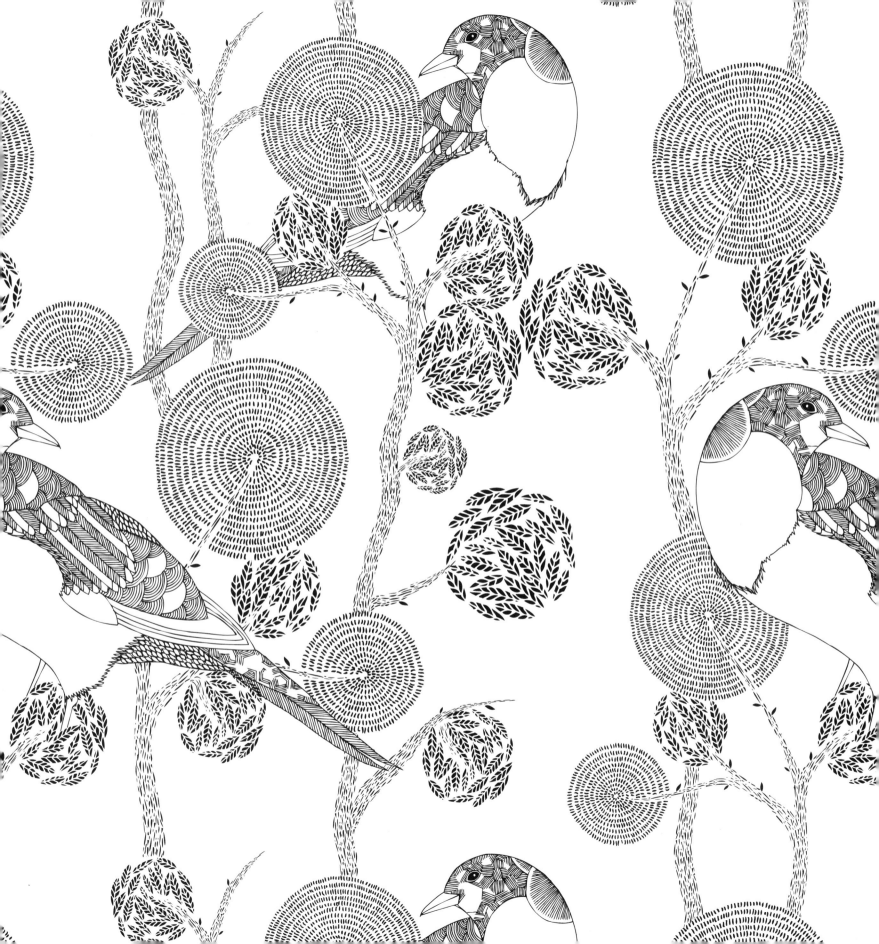

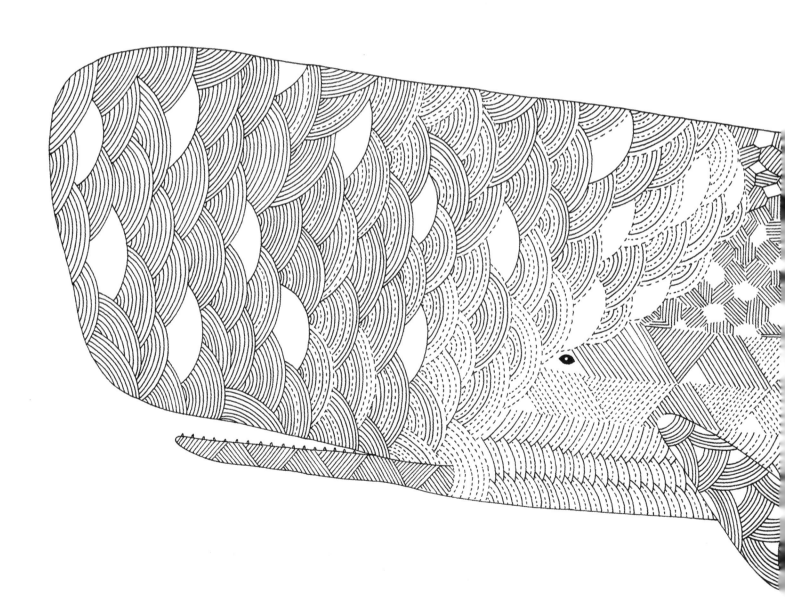

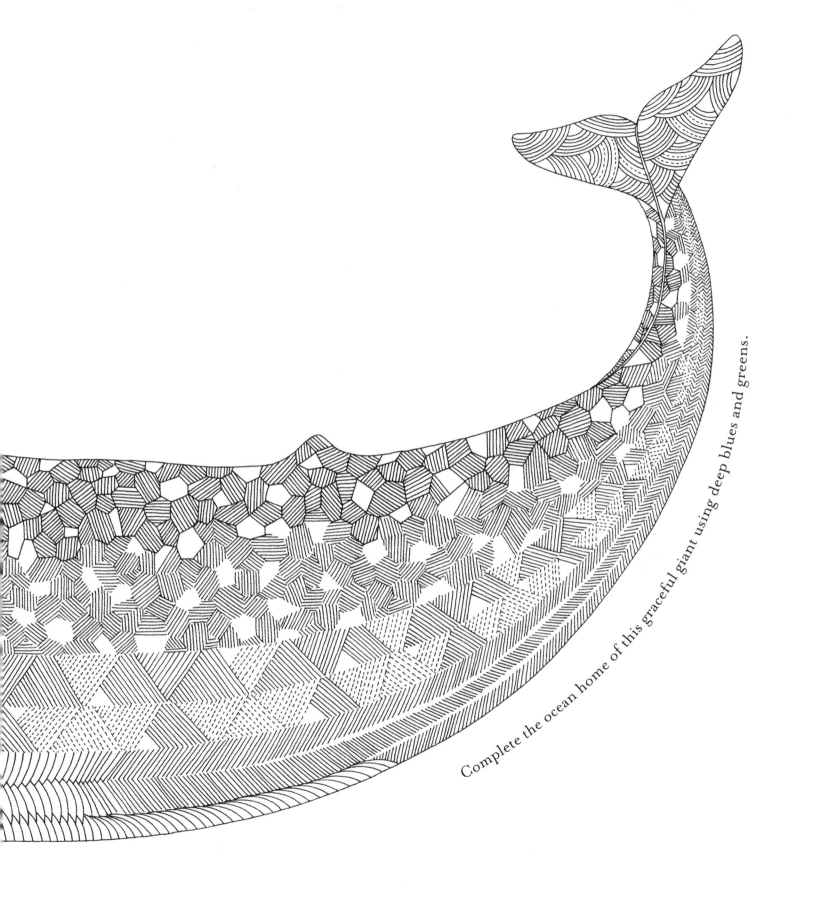

Complete the ocean home of this graceful giant using deep blues and greens.

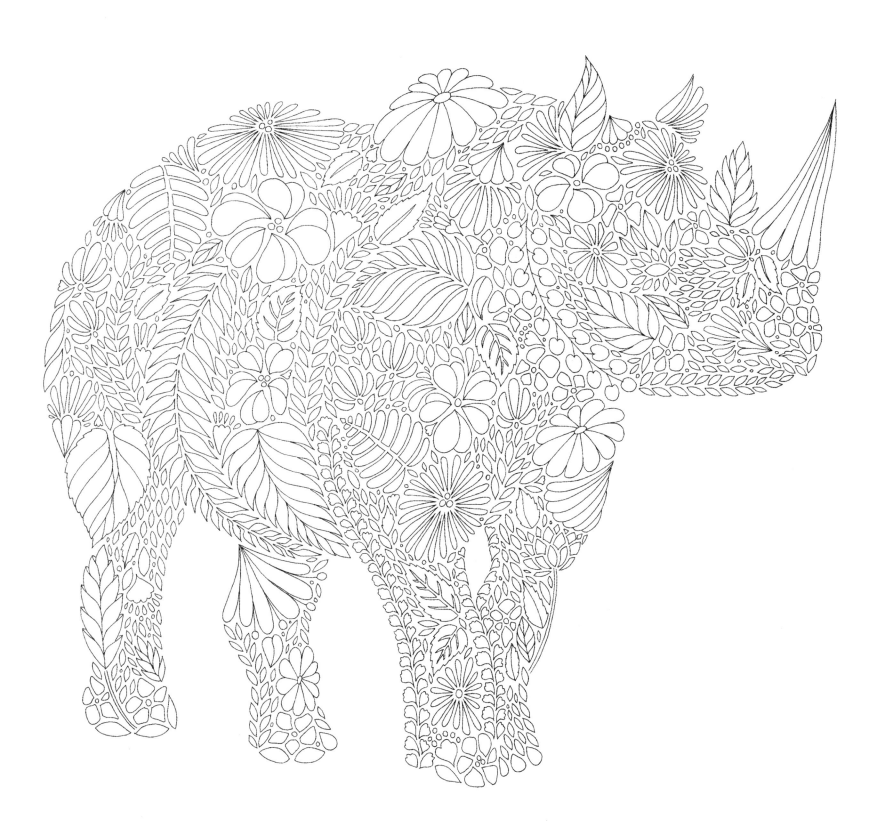

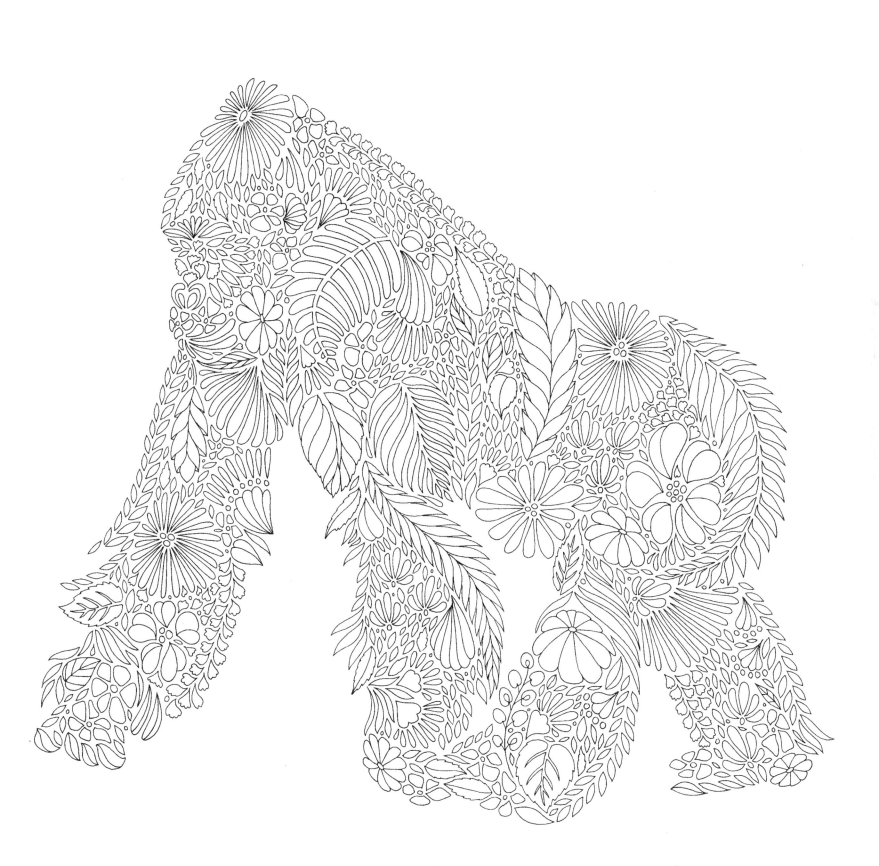

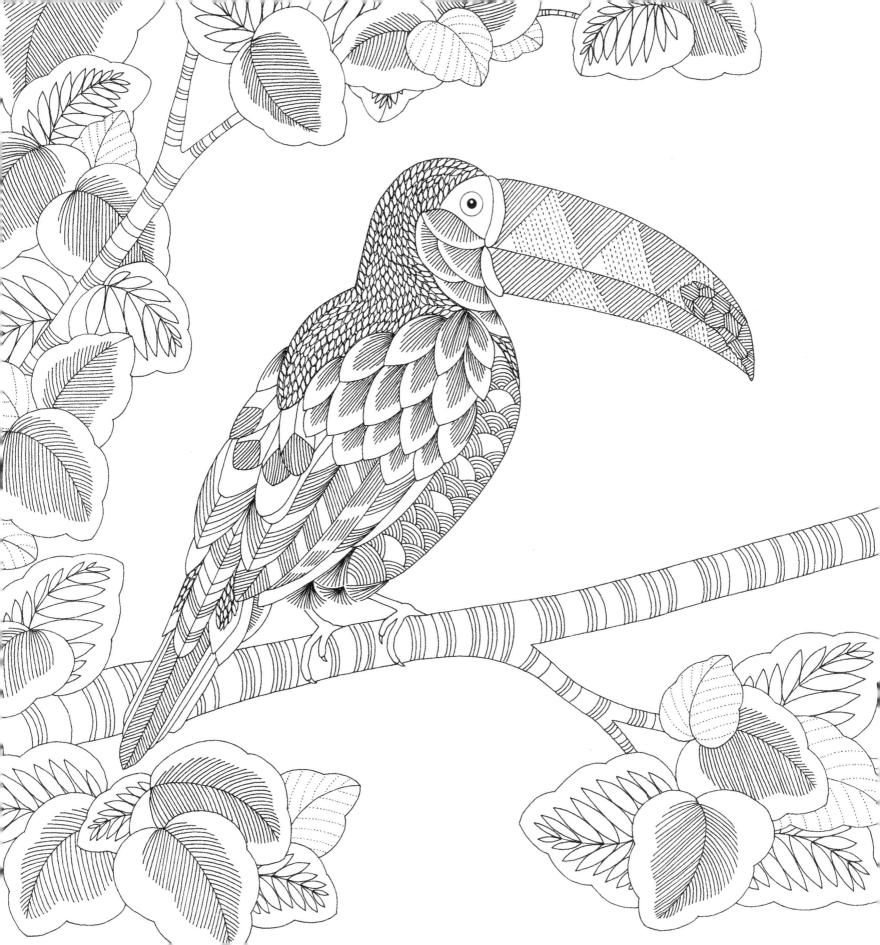

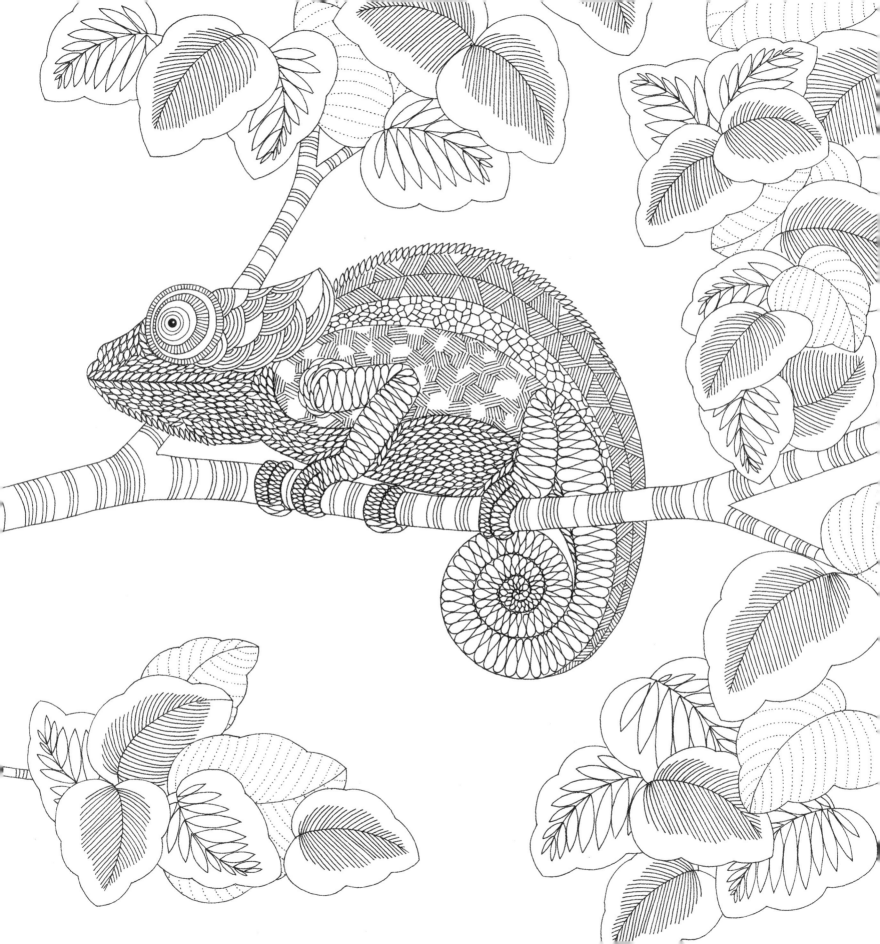

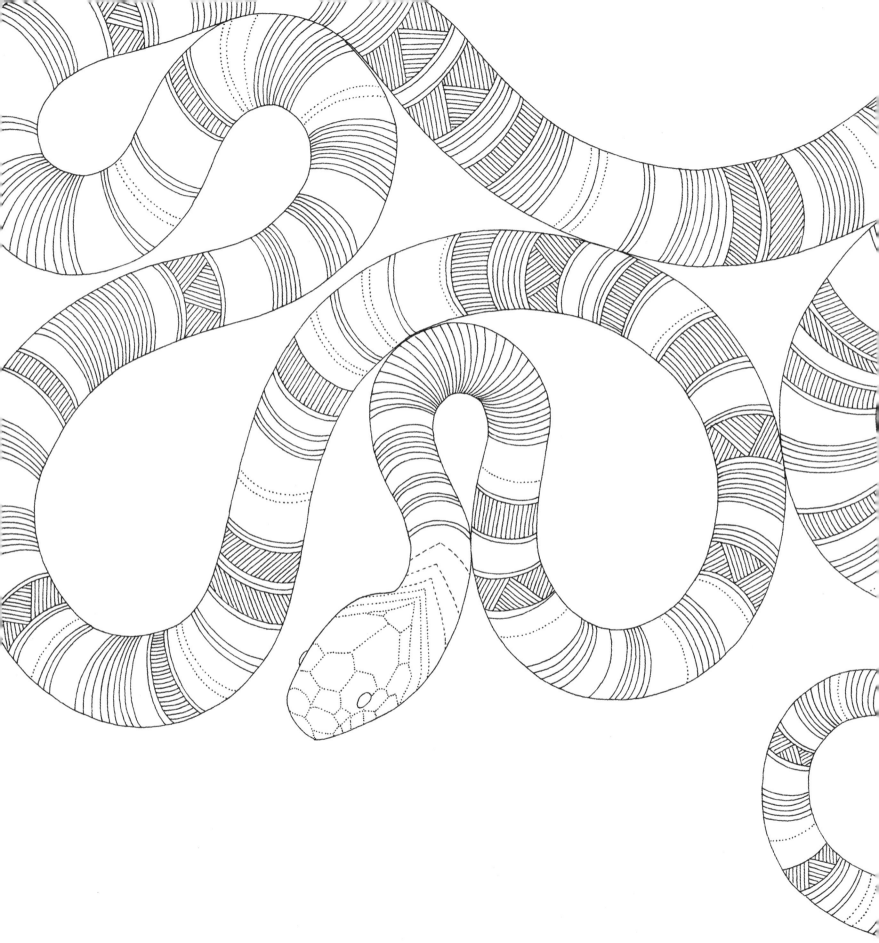

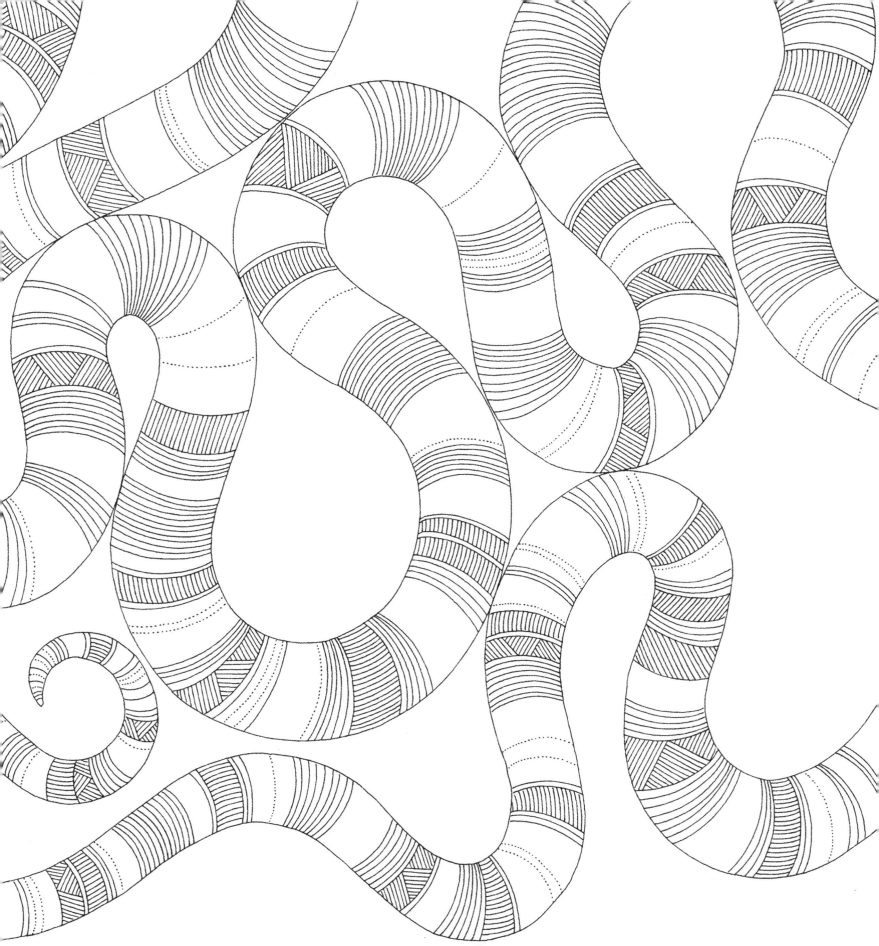

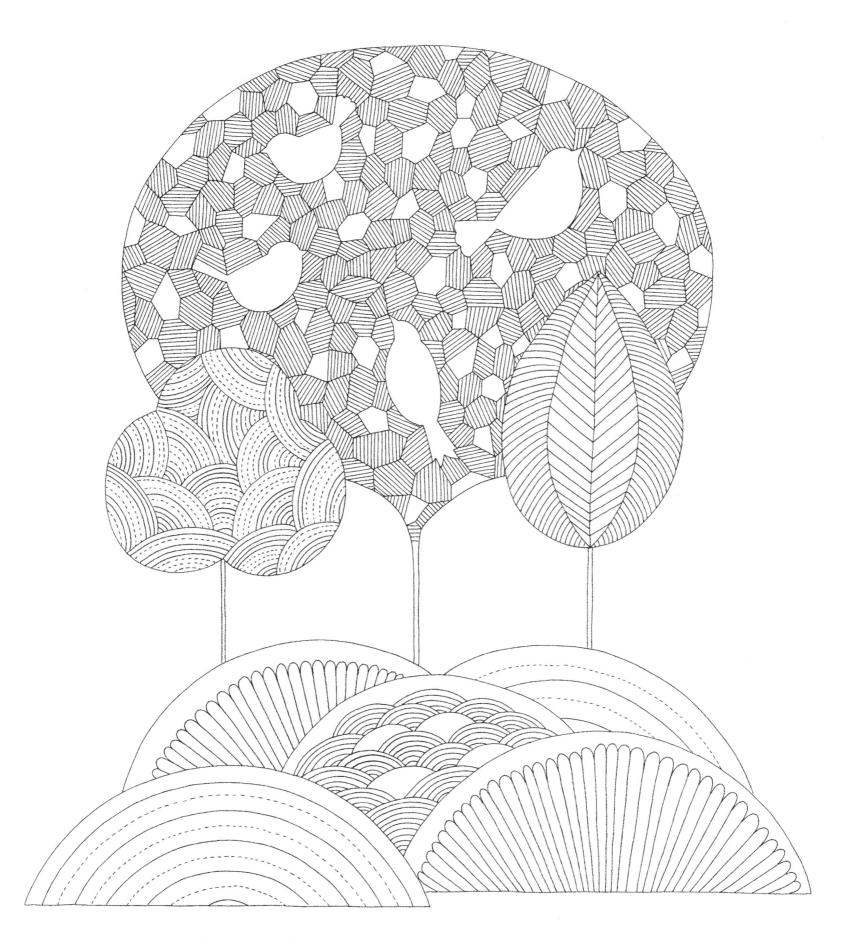

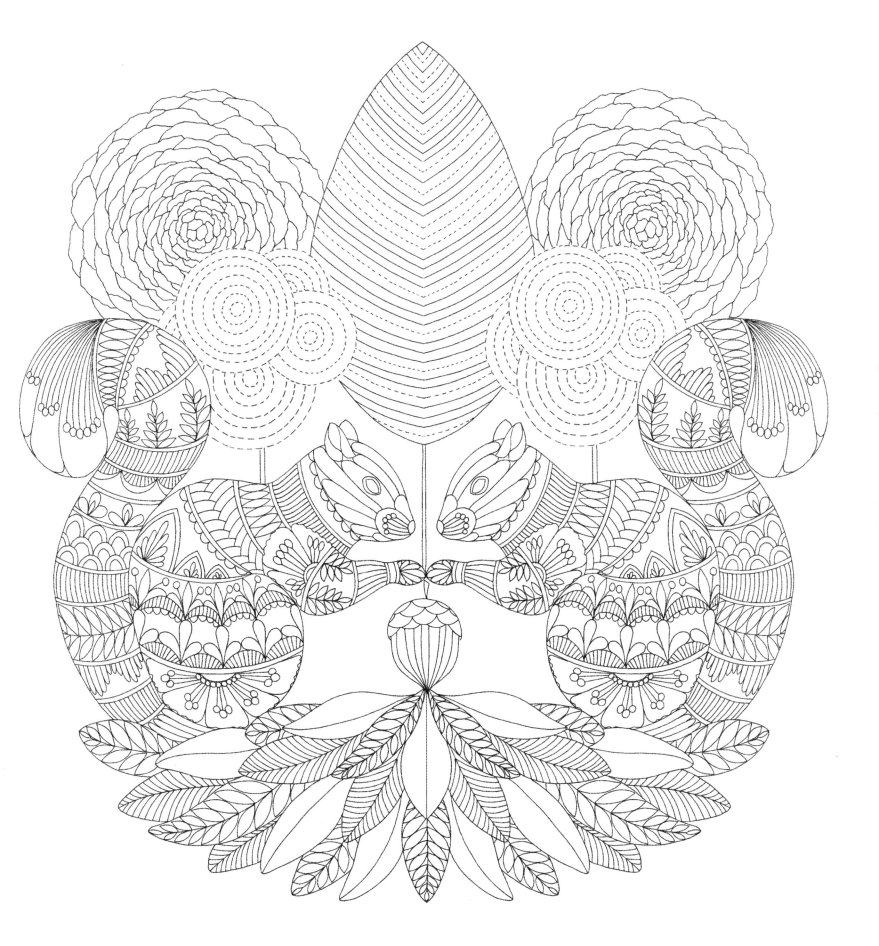

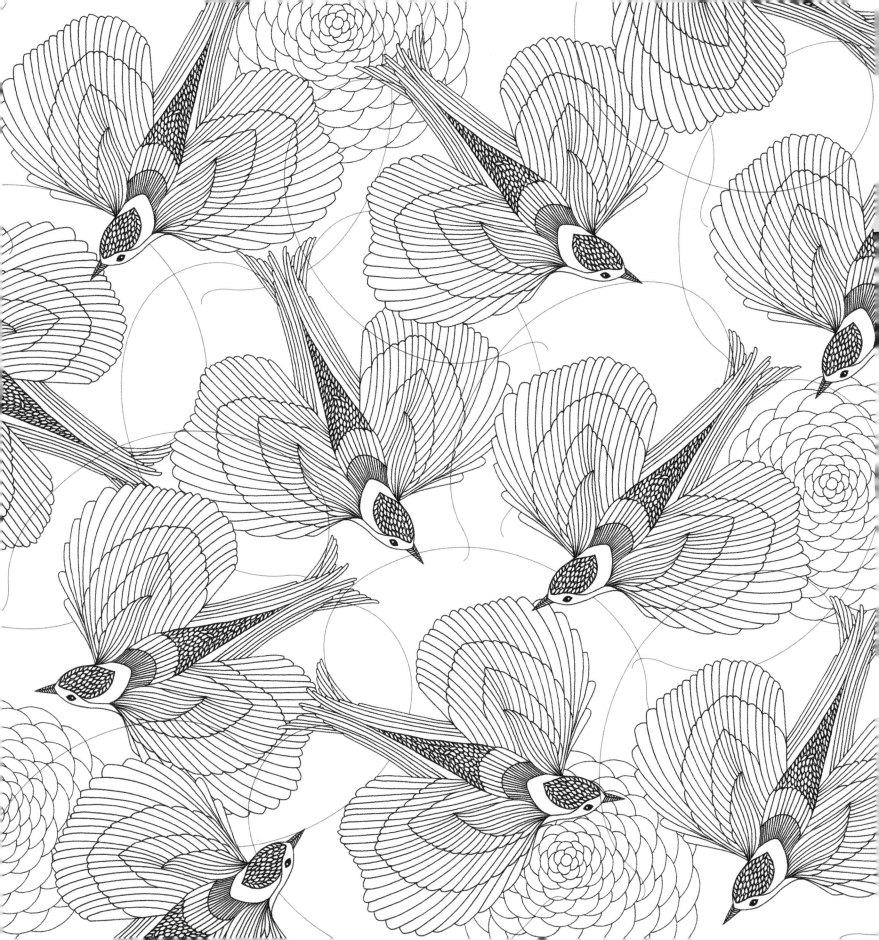

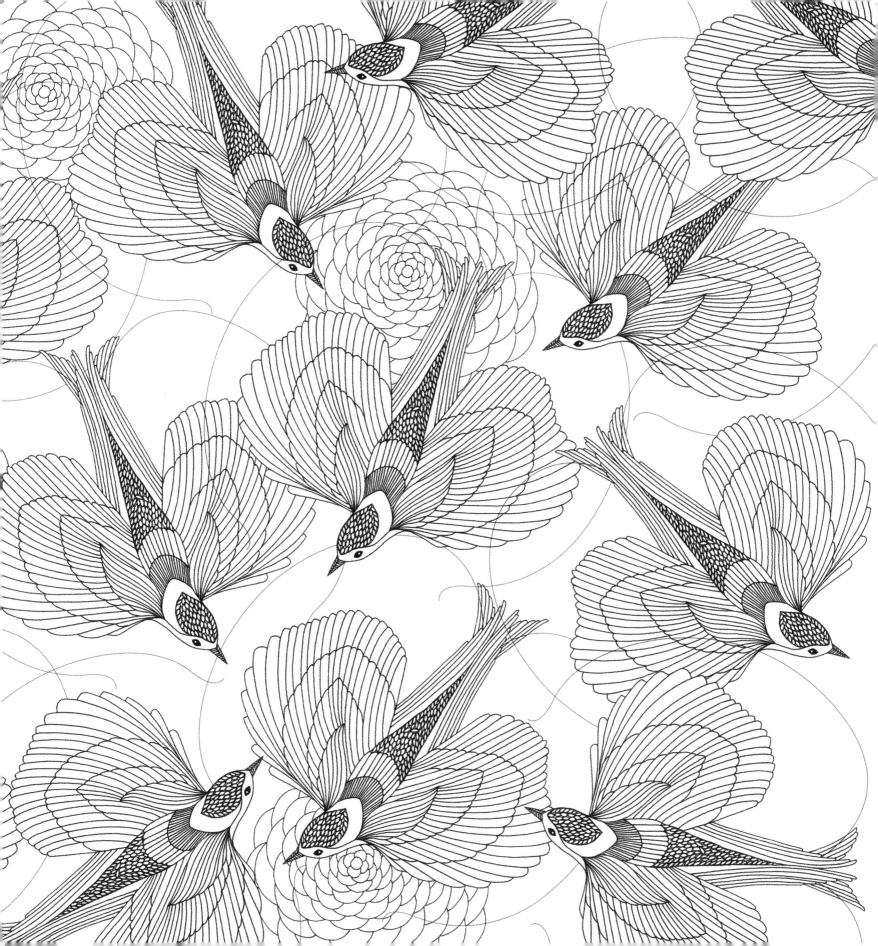

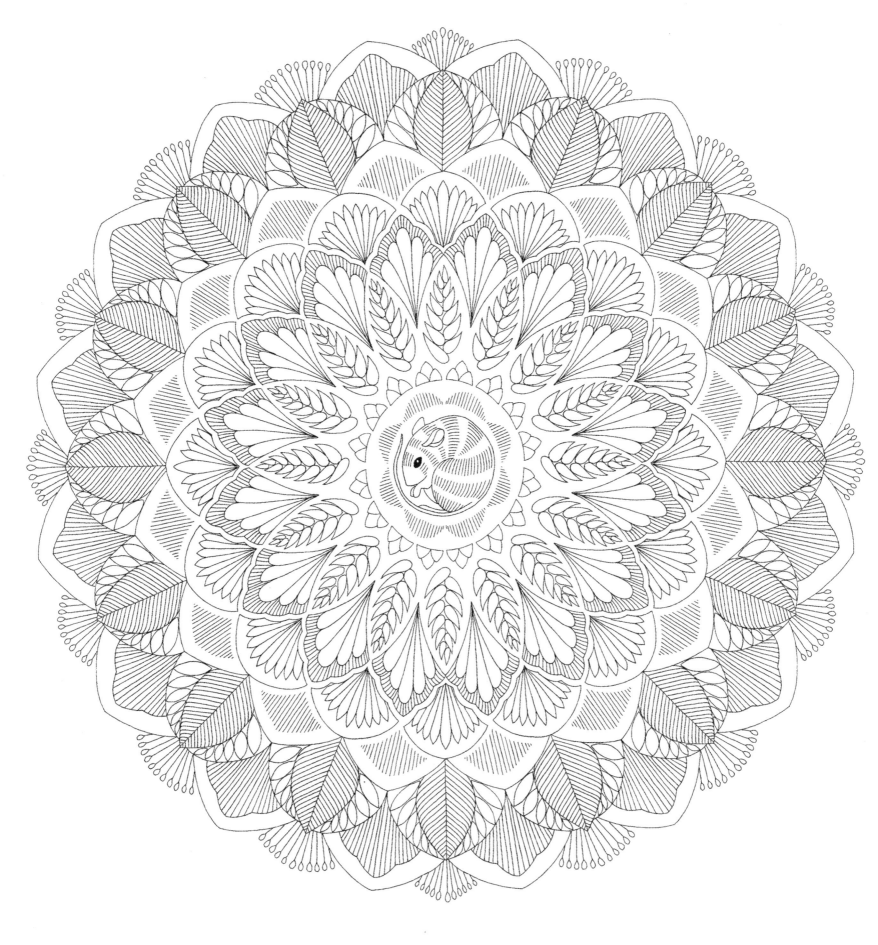

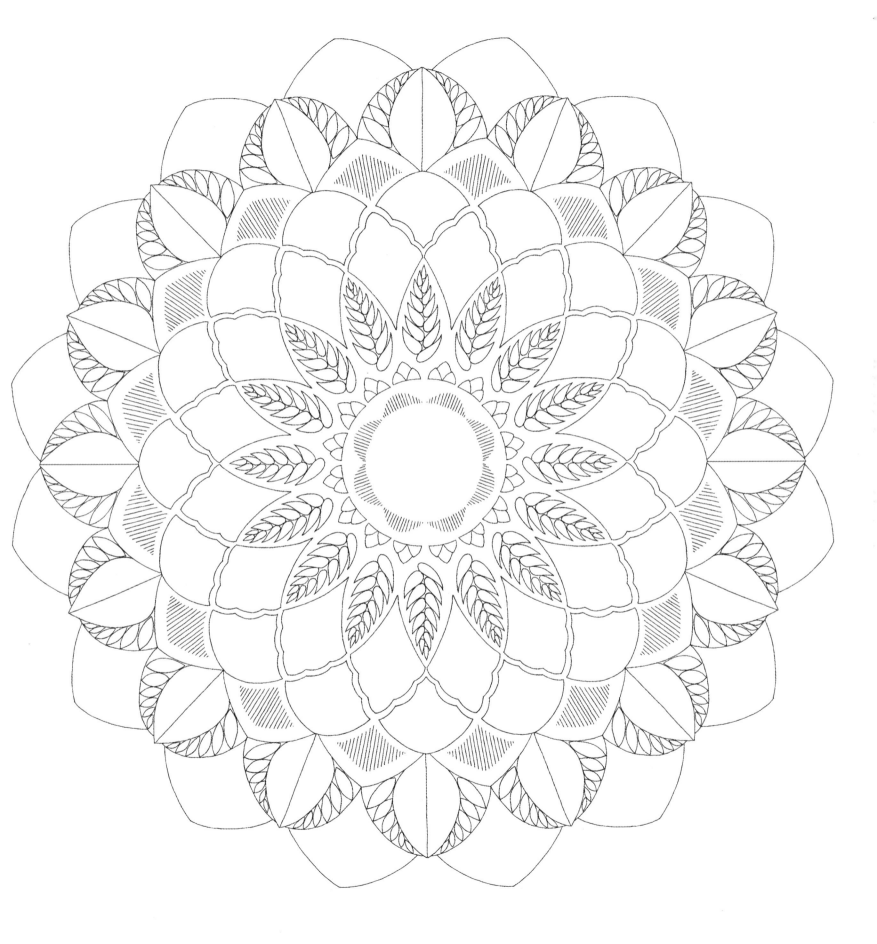

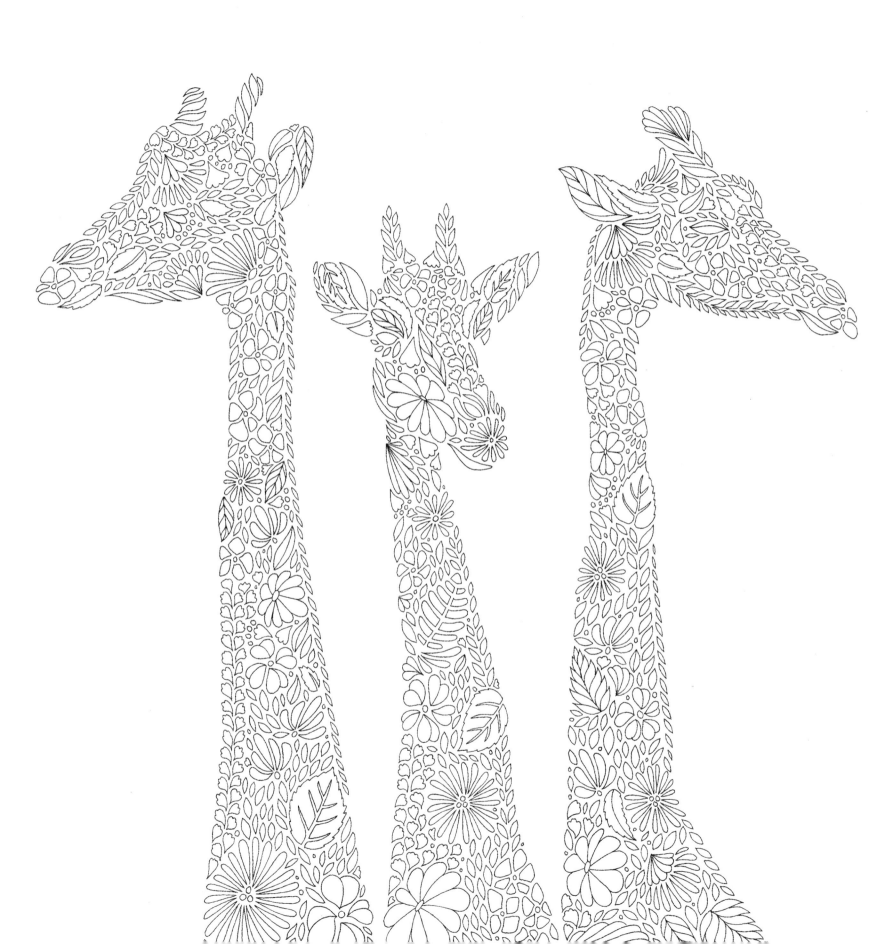

The hippo loves to wallow in the mud. Take the chance to fill him with color.

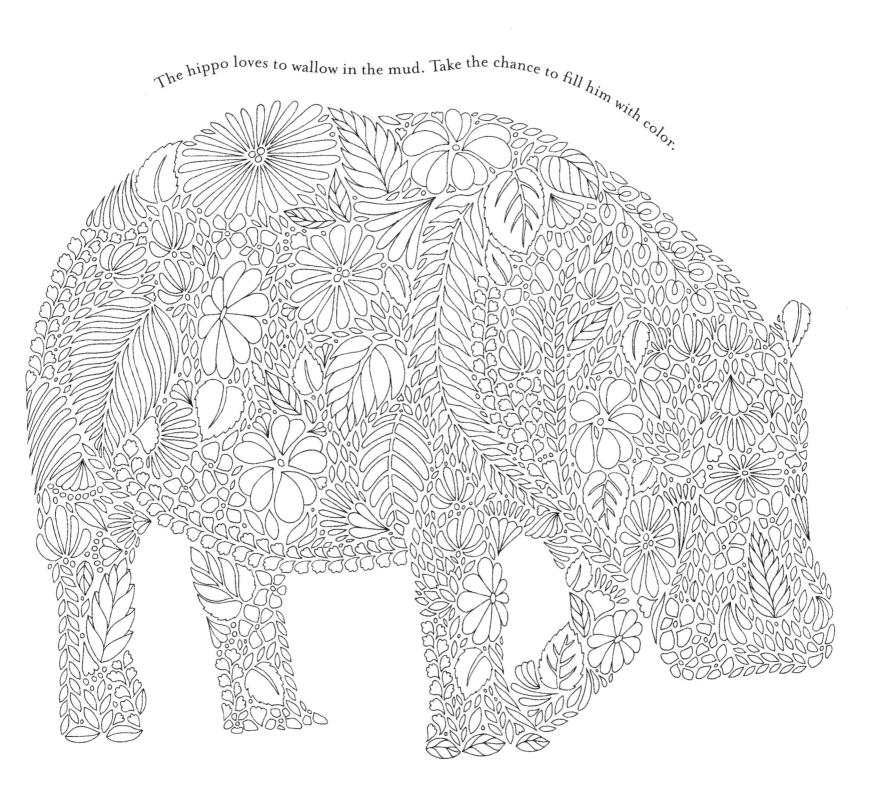

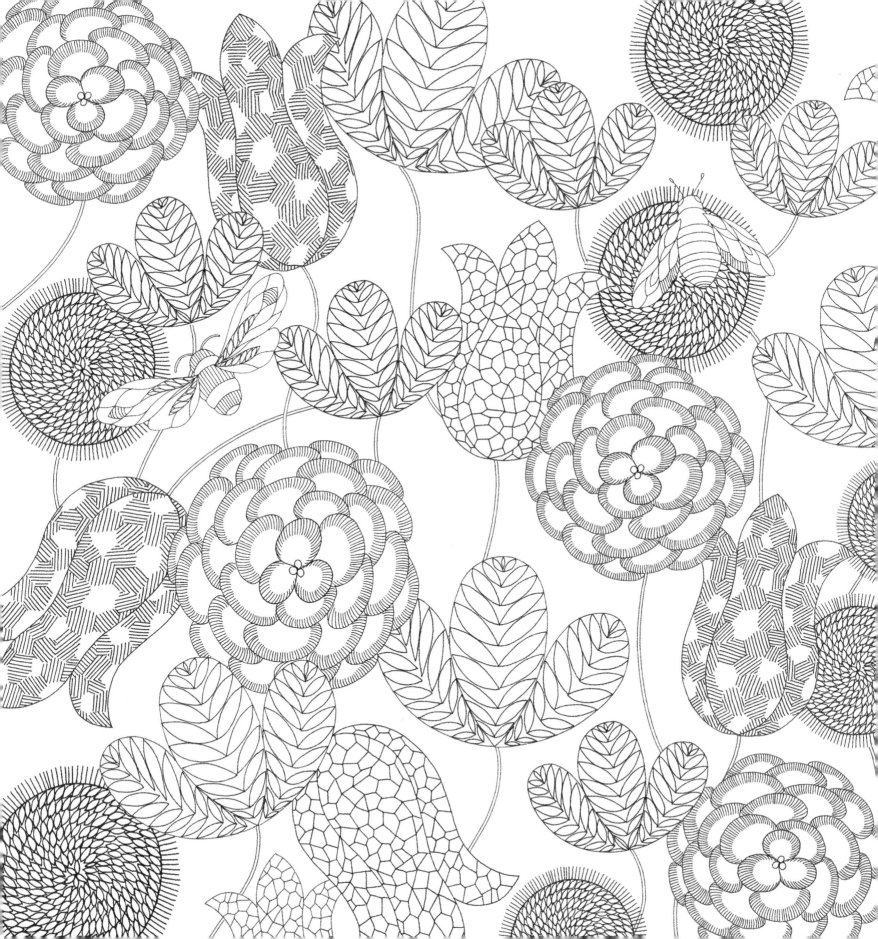

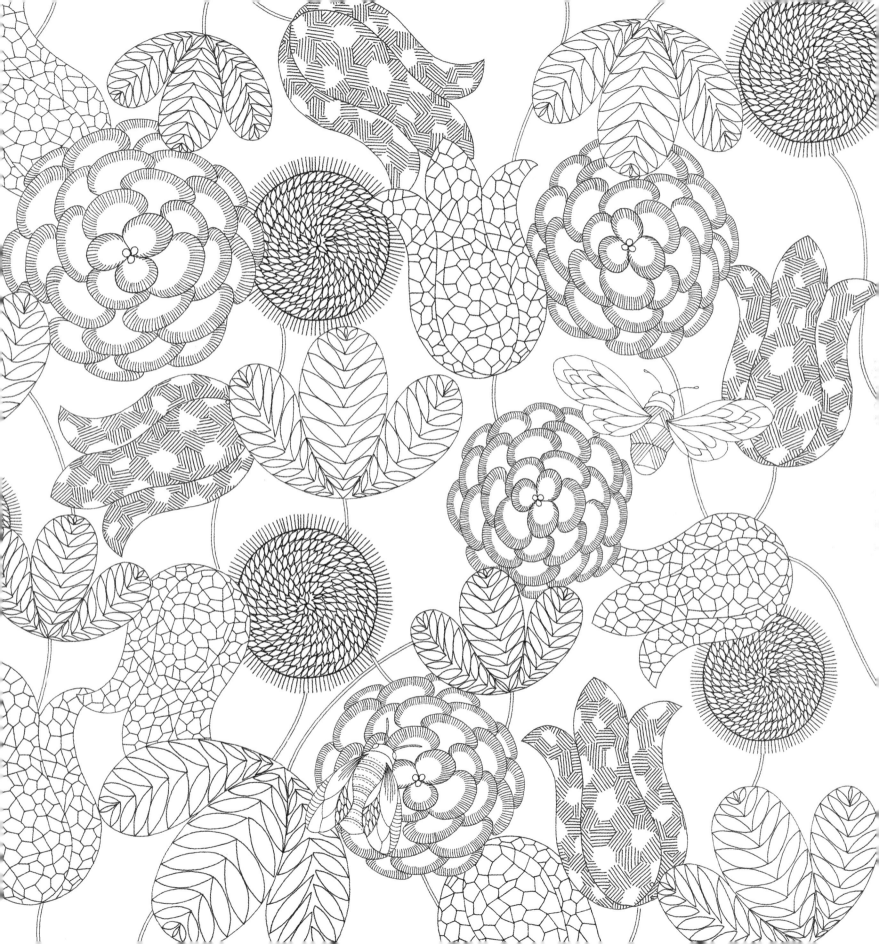

The snail lives in his shell. Help to decorate his home.

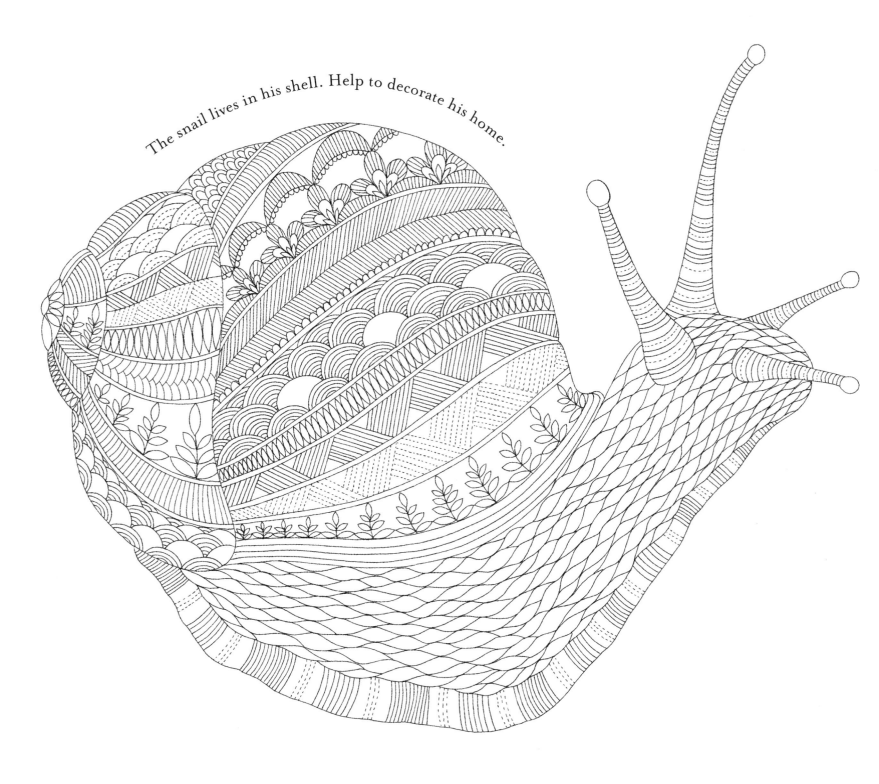

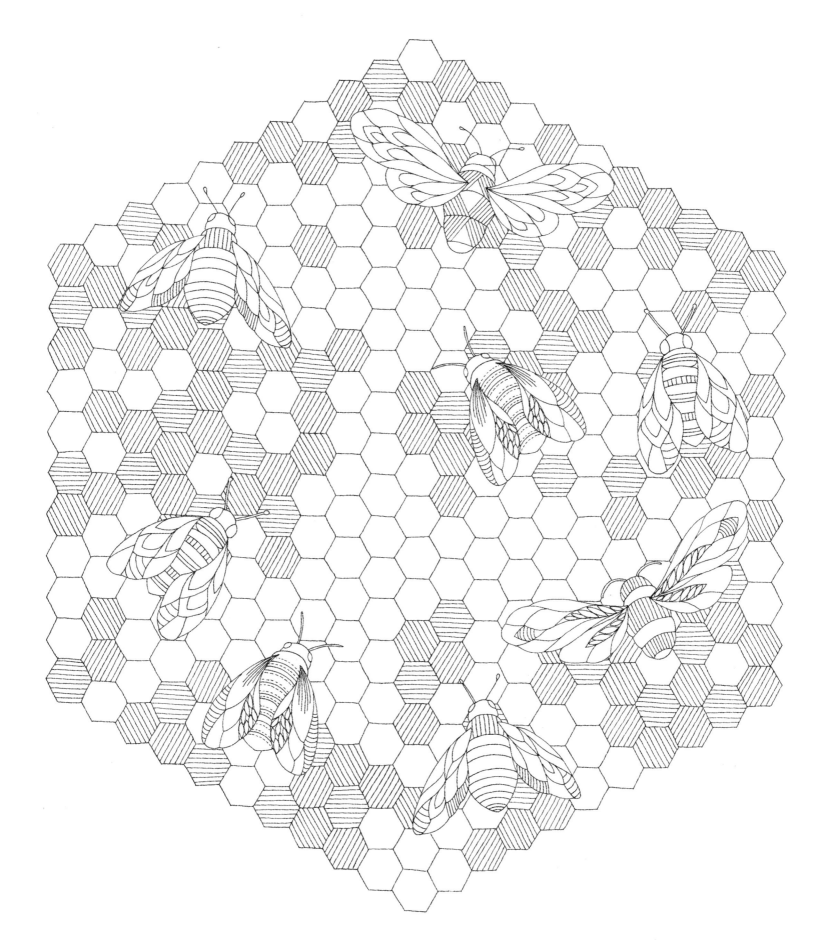

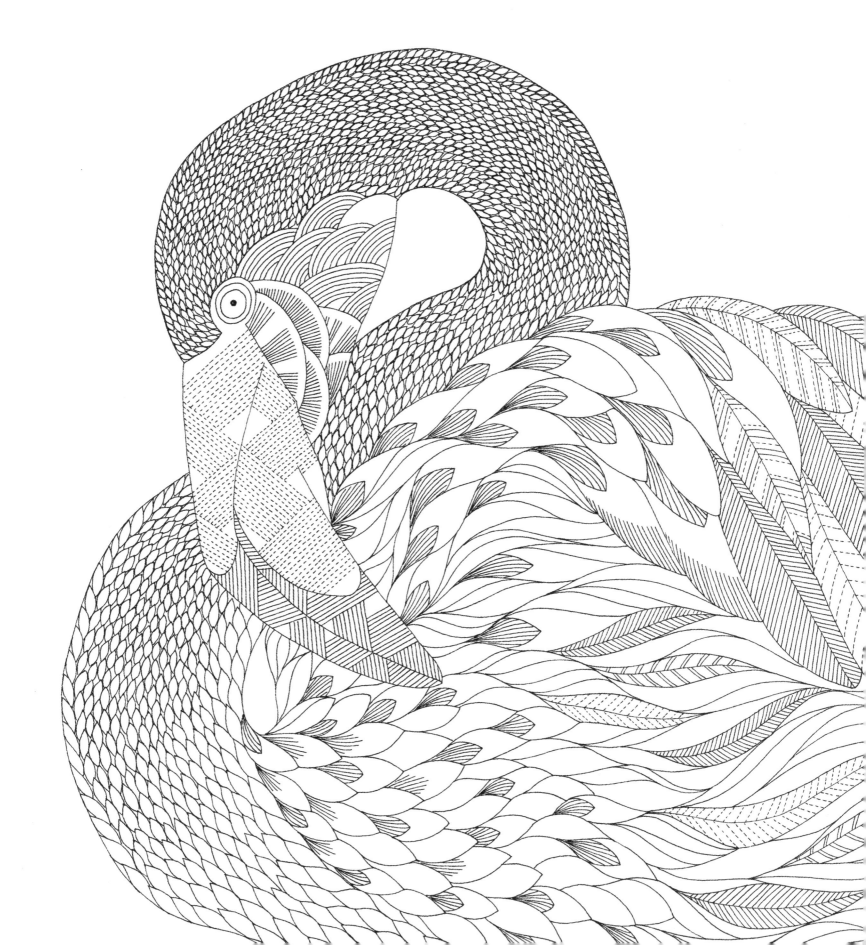

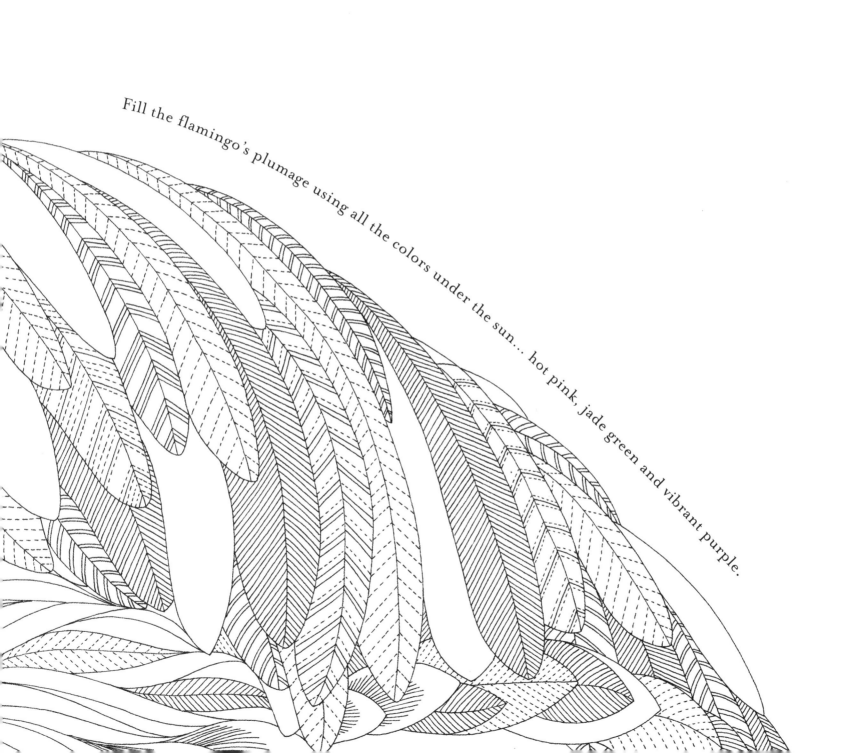

Fill the flamingo's plumage using all the colors under the sun... hot pink, jade green and vibrant purple.

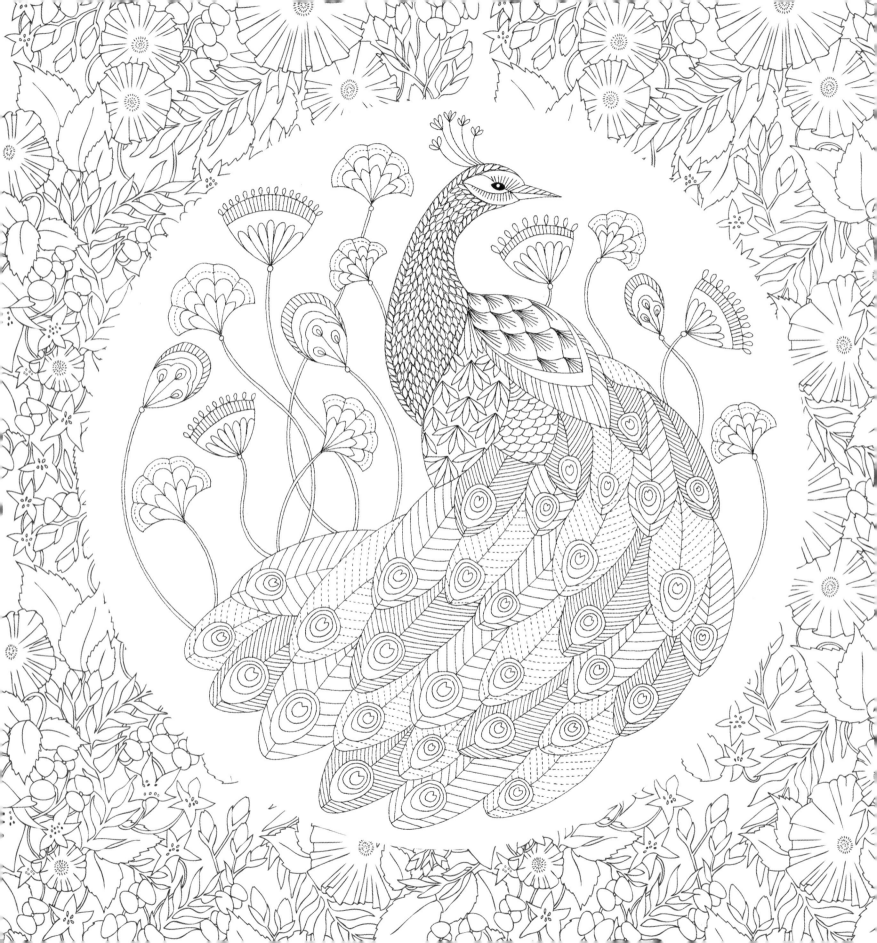

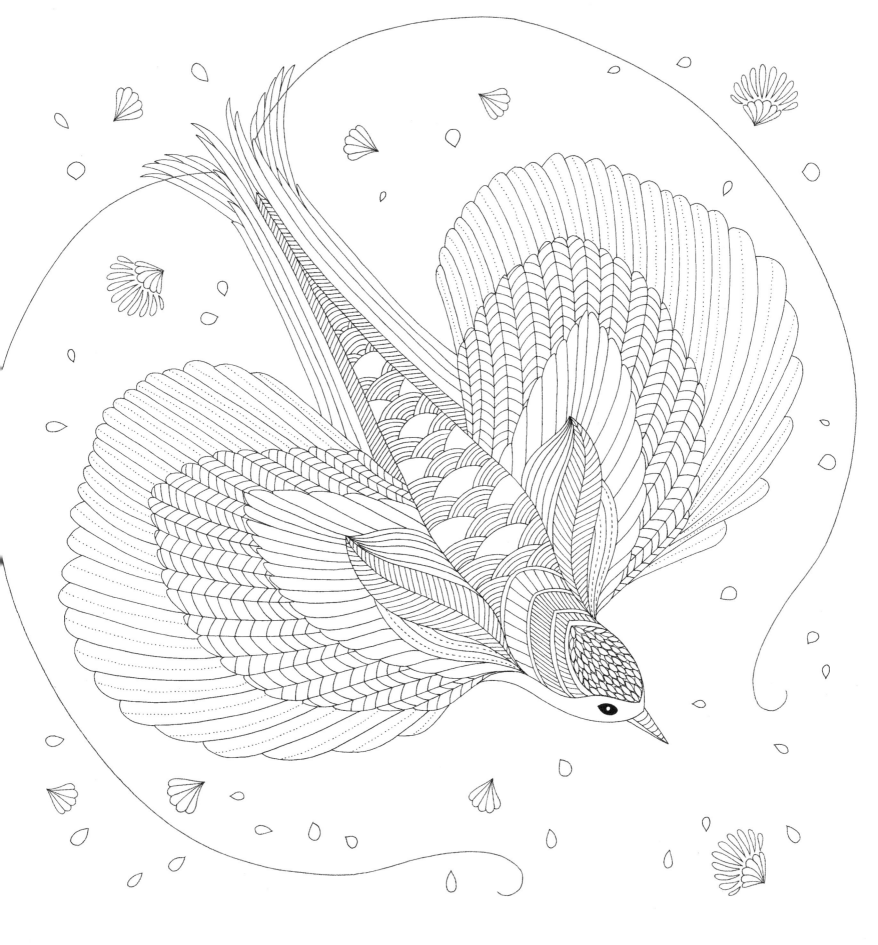

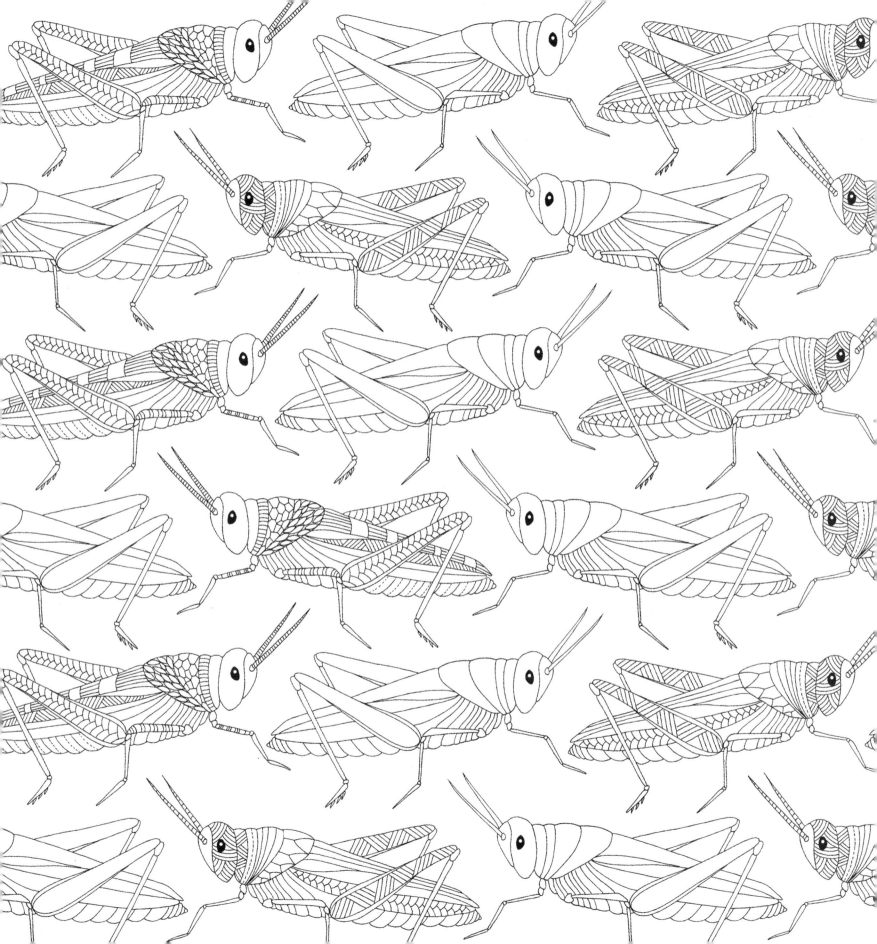

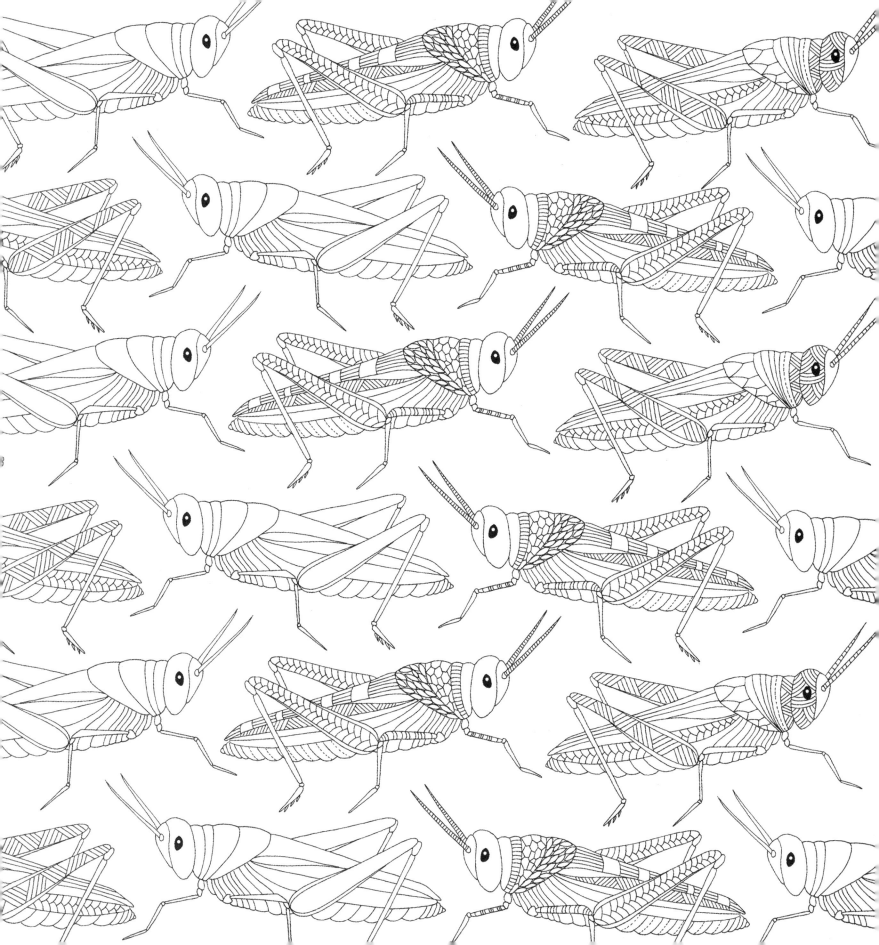

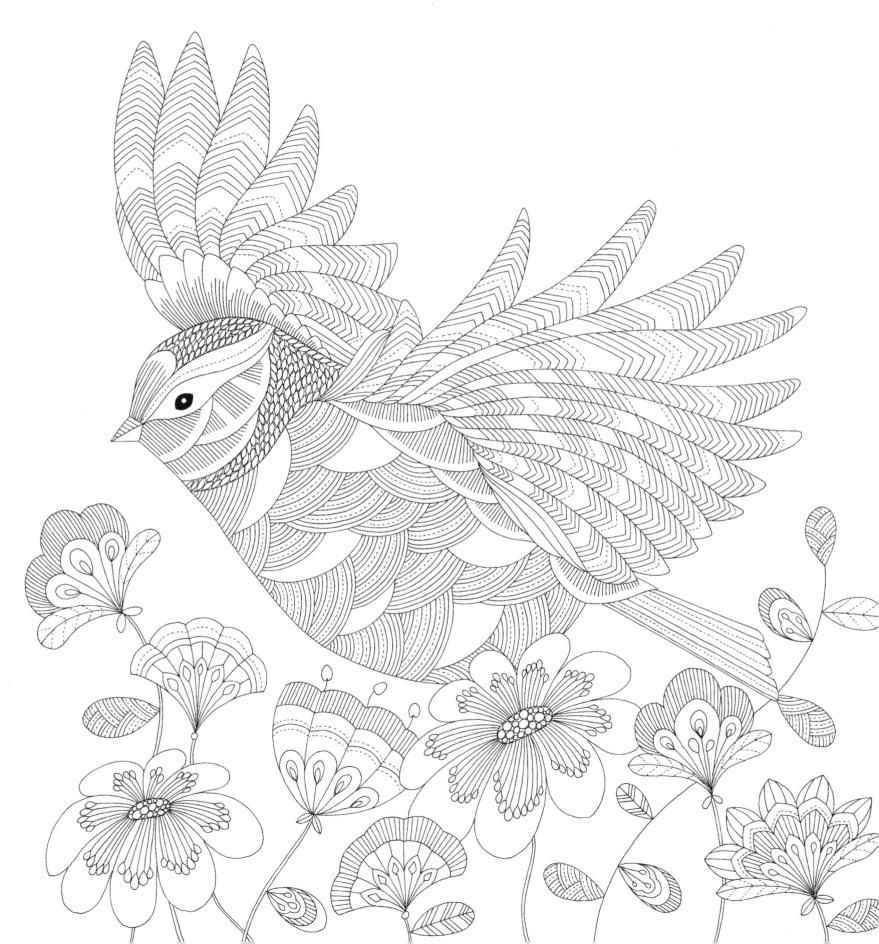

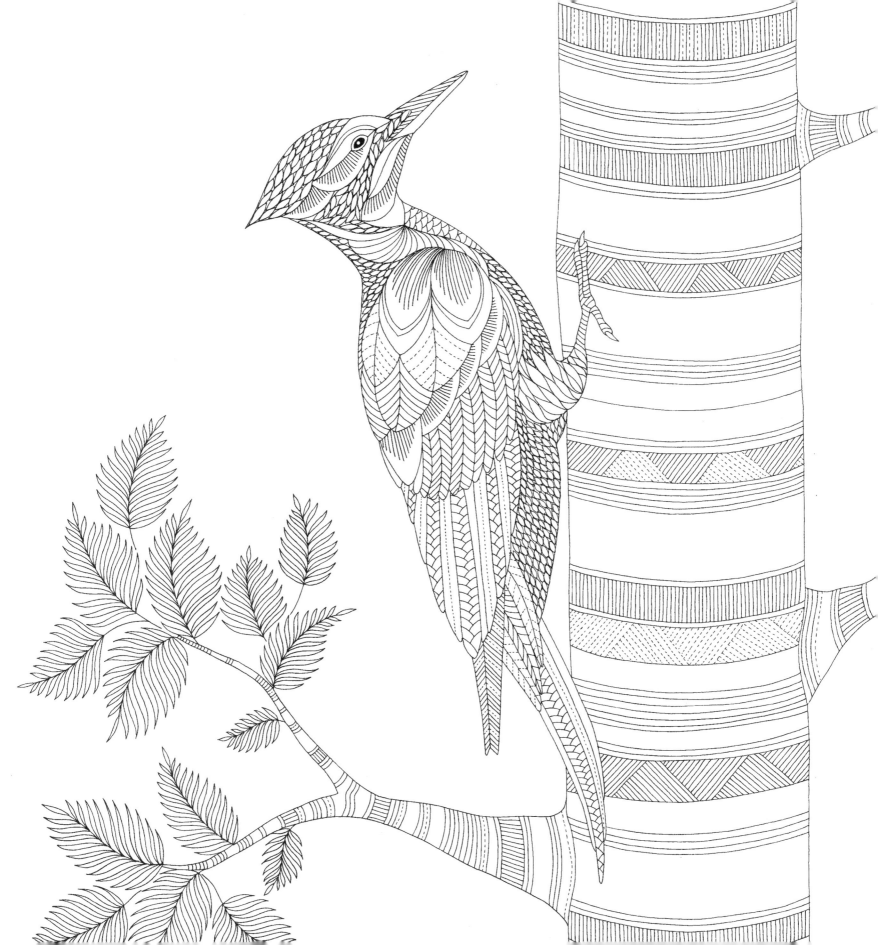

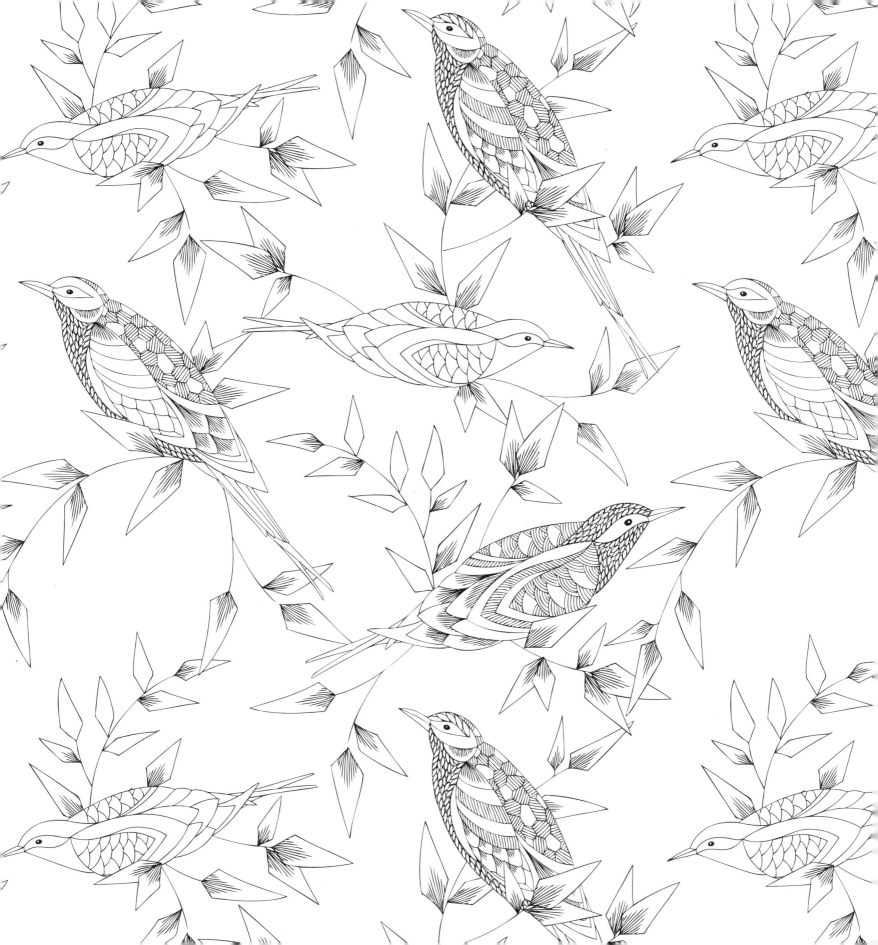

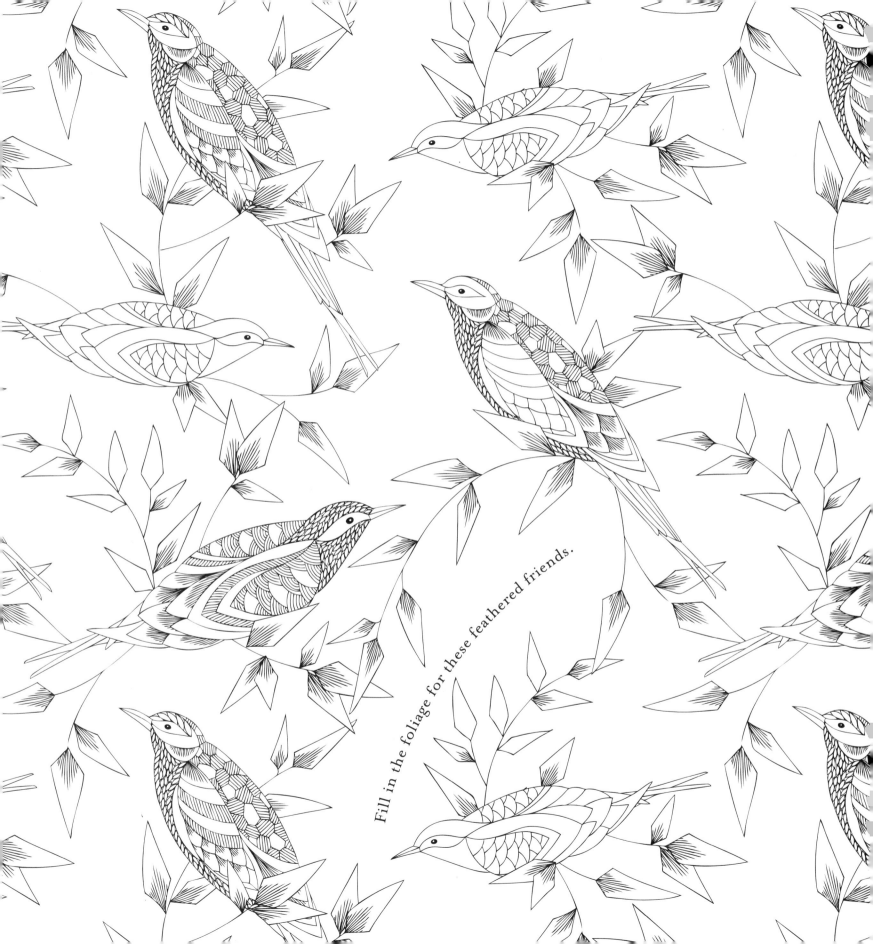

Fill in the foliage for these feathered friends.

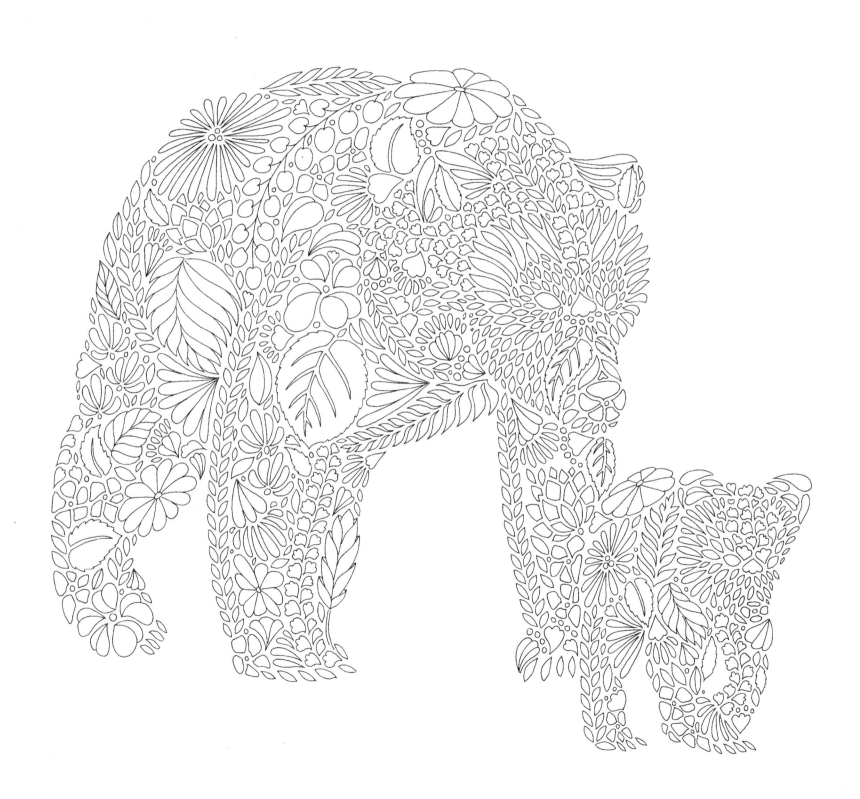

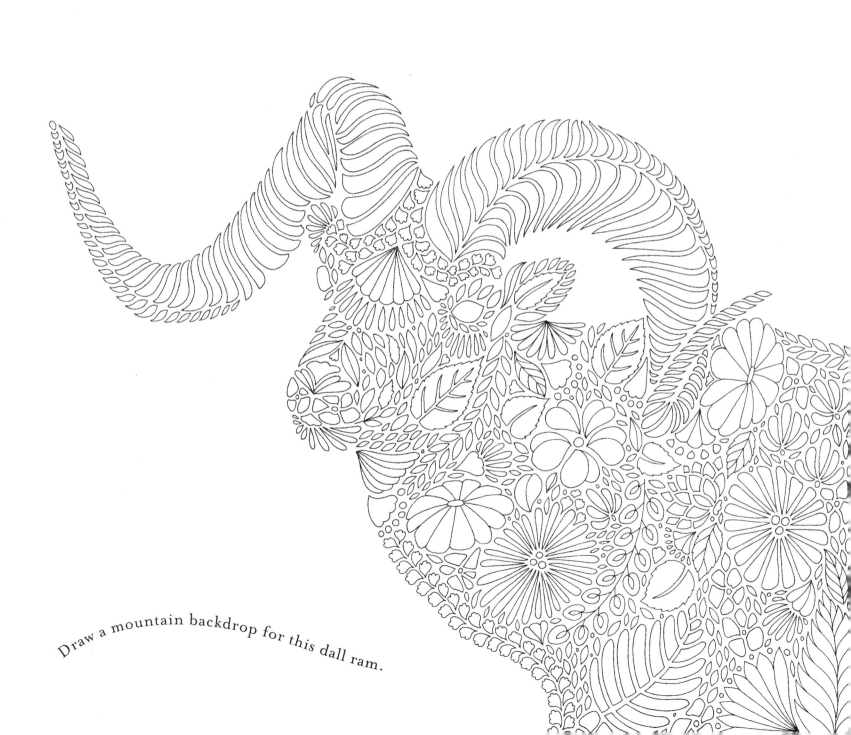

Draw a mountain backdrop for this dall ram.

Create an animal kingdom of your own…